IMAGES
of America

LITTLE ITALY

ANCHOR LINE

MEDITERRANEAN SERVICE
PROPOSED SAILINGS
FROM NEW YORK TO NAPLES
VIA GIBRALTAR
(SUBJECT TO CHANGE)

S. S. CALABRIA	Saturday,	March	7, 1914,	3 P.M.
" PERUGIA	"	March	28, "	10 A.M.
" ITALIA	"	April	18, "	2 P.M.
" CALABRIA	"	May	2, "	"
" PERUGIA	"	May	23, "	"

THIRD CLASS PASSAGE RATES
OUTWARDS

TO		TO	
NAPLES GENOA MESSINA PALERMO GIBRALTAR	$35.50	Piraeus or Patras	$42.50
		Alexandria . .	45.50
		Jaffa (Syria) . .	47.50
		Beyrouth (Syria)	48.50

Children 5 and under 10 years, half fare.
Children 1 and under 5 years, quarter fare.
One infant, free.

These Steamships are fitted with MARCONI WIRELESS TELEGRAPH and lighted throughout by ELECTRICITY. Excellent accommodations and good service.

21—24 State St.,
New York, Feb. 20, 1914

HENDERSON BROTHERS,
General Agents.

Many Italian immigrants were called "Birds of Passage" throughout the period of the mass migration because they went back and forth between Italy and New York City in a "return migration" in pursuit of seasonal labor. To accomplish this, they needed travel agents. The Anchor line promises departures to various points in Italy for $35.50.

IMAGES
of America

LITTLE ITALY

Dr. Emelise Aleandri

ARCADIA
PUBLISHING

Copyright © 2002 by Dr. Emelise Aleandri
ISBN 978-0-7385-1062-0

Published by Arcadia Publishing
Charleston, South Carolina

Printed in the United States of America

Library of Congress Catalog Card Number: 2002106358

For all general information contact Arcadia Publishing at:
Telephone 843-853-2070
Fax 843-853-0044
E-mail sales@arcadiapublishing.com
For customer service and orders:
Toll-Free 1-888-313-2665

Visit us on the Internet at www.arcadiapublishing.com

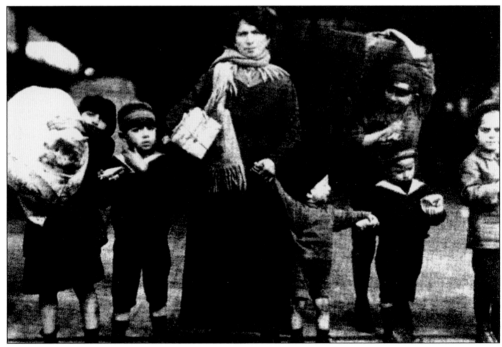

This immigrant mother is about to leave Italy with children in tow. The earliest Italian immigrants were single men who came to New York City to find work. They sometimes had to work for years before being able to save enough money to send for their wife and children back home in Italy. Thus, women would have to make the voyage alone or with their children, who often had no memory of the father they were meeting.

CONTENTS

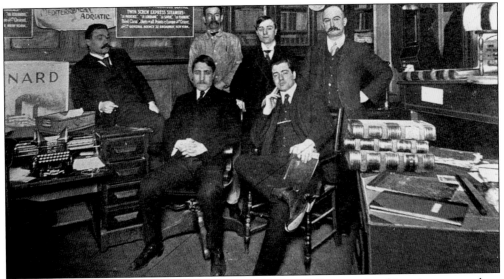

Vincenzo De Luca's bank and travel agency at 186 Grand Street assisted immigrant travelers. De Luca came from his native Cerisano, Cosenza, in Calabria, in 1883 and became the owner of several agencies: this one located in a building he erected himself, one at 157 Mulberry Street, and another in Pittsburgh, Pennsylvania. Surrounded by travel posters, members of his staff pose for the camera c. 1906.

Acknowledgments

Much gratitude on the author's part is due for the generosity and support of many friends, colleagues, and institutions. For their donation of time, information, pictures, or permission for the use of pictures, my appreciation goes to the following: Olga Barbato, past president of the Italian Actors Union; Rita Berti; the late Al Carr and his family; Lucy Codella and Nardina Trotta of the Order Sons of Italy Dr. Vincenzo Sellaro Lodge No. 2319; John De Lutro of the Palermo Caffe; the DeMattia family: Victoria Zecchino, Robert DeMattia, and the late Joseph DeMattia; Dona DeSanctis of the Order Sons of Italy in America; the DiPalo and Santomauro families—Luigi, Salvatore, and Marie; Denise Mangieri DiCarlo; the late Vincent Gardenia; the Garibaldi-Meucci Museum; the Italian Academy for Advanced Studies in America at Columbia University; the Italian Food Center; the Lepore family of Ferrara's—Alfred, Anna Maria, Adelina, and Gabriella; Jean Mandracchia and family; the late Marietta Maiori-Giovanelli and her daughters Adele Rosato and Olga Cannalonga; the Migliaccio family—Blanche, Arnie "Mig," and Adele Abolasia; the Municipal Library of New York City; Louise Camera Pomilla; Rita Romeo; the late Michael Sisca, publisher of La Follia; Fr. John F.X. Smith of Our Lady of Mount Carmel Church in Tuxedo, New York; Rudy Vecoli and Joel Wurl of the Immigration History Research Center at the University of Minnesota; Dolores Zacconi and family; and Diana Zimmerman and Maria Del Giudice of the Center for Migration Studies.

The author wishes to thank Charles Mandracchia for his computer graphics skills and assistance with photographs; Tom Arkin and Laura Giacomelli for their assistance in taking photographs; Mark Clayton for his computer assistance with photographs; and Vanessa Vacchiano.

All other photographs are from the author's personal collection, except the Grand Theatre on page 93, courtesy of the Museum of the City of New York; the Italian music hall, page 95, courtesy of the New-York Historical Society; and many pictures, too numerous to list, courtesy of the Center for Migration Studies.

INTRODUCTION

New York City's Little Italy, *La Piccola Italia*, has always been a state of mind as well as a geographical location. The Italians and the Eastern European Jews who arrived after the 1880s tended to live in ghettos more than did immigrant groups who had preceded them earlier in the century, partially because of language. The late-19th-century Italians thought of themselves collectively as an Italian colony, *La Colonia*. The colony included Italians of all five boroughs, where many "Little Italies" eventually emerged—such as the Belmont section of the Bronx and in South Brooklyn and Bensonhurst—and even towns in nearby New Jersey that had frequent and daily contact with the Italians of the city. Manhattan's Italian neighborhoods were localized but spread out all over the island: Italian East Harlem; West Greenwich Village and what is now SoHo; the pocket in the vicinity of West 110th Street and Amsterdam Avenue; East Greenwich Village; and, of course, *the* Little Italy, the downtown area of the Lower East Side, straddling Canal Street, east and west, the subject area of this book. Today, common parlance identifies this neighborhood as Manhattan's Little Italy.

At the center of what became Little Italy was once a 135-acre farm owned for most of the 18th century by the Holland-born French Huguenot Nicholas Bayard and his family. The family's homestead was situated on a hill just above what is today the intersection of Hester and Mott Streets and overlooked the sylvan setting of the Collect (from the Dutch *Kalchhook*) freshwater pond, a five-acre lake just to the west. As the city expanded, the region surrounding the lake became occupied by pottery works, tanneries, tobacco merchants, rope works, slaughterhouses, and Coulthardt's Brewery (which, in a few decades, would become a noxious, five-story tenement slum-turned-mission house). The industries polluted the Collect and, between 1802 and 1817, the Common Council had the pond filled with soil by leveling Bunker Hill, just north of what is now Grand Street between Mott Street and Broadway. The year 1817 saw the extension eastward of Anthony Street (now Worth Street) to meet Orange Street (now Baxter Street) and Cross Street (formerly Park, now Mosco Street), thus forming the five-spoke intersection known as Five Points, a notorious name that came to refer to the entire surrounding neighborhood, also described as the "Bloody Ole Sixth Ward." Its loose boundaries were Canal Street, Broadway, and points east of Chatham Street (later Park Row) and the Bowery to the East River—in other words, a large portion of the future Little Italy.

The Collect business owners, among them the Lorillards, the Schermerhorns, and the Ashdors (later known as the Astors), kept their land and began developing the area, building two-story wooden houses, which served as both living and working space for an artisan class

that would soon become obsolete as industrial mass production took hold. The land, essentially a filled-in swamp, was unsteady, flooding in rain, disturbing building foundations, and festering disease, no longer the location of choice for the upper class. Some 25 percent of Five Points residents were unskilled immigrants by 1825, and 15 percent were African Americans (living mainly on Little Water Street). The 1830s, 1840s, and 1850s saw increased immigration to the city, first Germans and then Irish Catholics, all of whom needed inexpensive lodging near their work. They gravitated toward Five Points. To accommodate them, cheap, crowded tenement houses replaced the frame houses, as the more prosperous residents of earlier days moved up and out, leaving the neighborhood to the poor. The vicinity became rife with saloons, brothels, basement lodging houses, gambling dens, abandoned children, cholera epidemics, thieves, drunks, the unemployed, pickpockets, and streetwalkers.

By 1855, only 28 percent of the residents were native-born Americans, and 3 percent were Italian born, living mainly on Anthony and Orange Streets. In the early part of the 19th century, a number of northern Italian political and religious refugees, among them Lorenzo Da Ponte and Giuseppe Garibaldi, emigrated to New York City but for the most part lived on the borders of Five Points, while many of the poorer early Italian immigrants lived within. As immigration increased, former immigrant groups that had become more established moved on. By 1870, the U.S. census counted 2,790 Italians already in residence in New York City. The Italian newspaper *L'Eco d'Italia* dubbed Five Points "Le Boulevard des Italiens." In the 1870s, a trickle began that would become the Italian and Eastern European Jewish mass migration of the next 50 years, completely changing the sounds, sights, and character of the entire Lower East Side. By 1890, 52 percent of New York's Italians inhabited what was now a thoroughly entrenched "Little Italy." The 1900 census showed that more than 225,000 Italians lived within New York City's boundaries alone. That was at the time greater than the population of Rome.

Throughout the first quarter of the 20th century, immigration statistics reveal a steady flow of new immigrant arrivals. However, the immigration quota laws of 1924 restricted the annual importation of new Italian immigrants into the United States and the neighborhood gradually began to see the effects of the restrictive quotas. Furthermore, as the second and third generations of Italian-Americans became acculturated, they moved to "the country" in sufficient numbers to form little Italian enclaves, such as Staten Island, Bensonhurst Brooklyn, and the "farms" in the Bronx and Queens, as well as in New Jersey, Long Island, and Westchester County. Today, Little Italy, *La Piccola Italia*, is more *piccola* than ever. What remains Italian is primarily the full length of Mulberry Street between Canal Street and Houston Street and the streets on either side of the intersections at Hester, Grand, Broome, Spring, and Prince Streets. The majority of the rest of the neighborhood accommodates the new Chinese and Asian immigration, thus continuing the practice the area has followed for the last two centuries.

—Emelise Aleandri
April 2002, New York City

Dedicated to Francesco Saverio Lamanna,
the son of the Barese iceman, Dan,
whose support made this volume possible.

One

EARLY DAYS

Mamma mia dammi cento lire
Che nell' America io voglio andar!

Nuovissima Canzonetta popolare

"Mamma, Mamma, Mamma, give me one hundred dollars, to America I would go," is the plaintive wail of the immigrant girl Rosina in this folk song that was popular at the beginning of the 20th century. In 1900, 100,000 new Italian immigrants entered this country; in 1904, 575,000. Although 20 to 30 percent of these migrants returned to Italy, having come here only to work, the greater part settled permanently, prompted by overpopulation and an unstable economy in Italy.

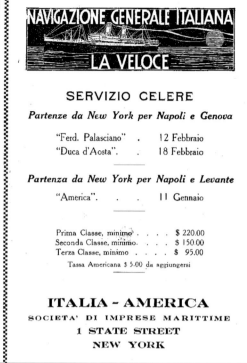

This advertisement for the Italian General Navigation Company promises swift service to Naples and Genoa, two of the three usual ports for immigrants. (The other was Palermo.) These 1921 prices, a whopping $95 plus a tax of $5 for third class, are a lot steeper than those formerly offered by the Anchor Line in 1914.

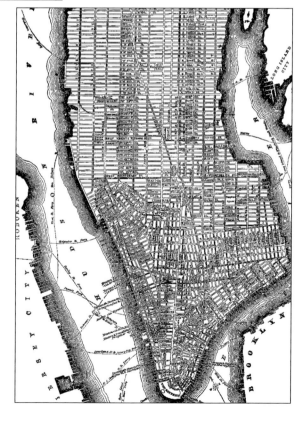

This 1876 map of Manhattan shows the island as it appeared to early Italian immigrants at the start of the mass migration. There are no bridges, though the gridiron structure is already in place. In Lower Manhattan, Mulberry Bend, named for the curve in Mulberry Street in the Chatham District, became the heart of the Italian *colonia*, bordered at its most populated on the north by Bleecker Street, on the south by Worth Street, on the west as far as West Broadway, and on the east by the Bowery.

In June 1805, due to political and religious pressures in Italy, Lorenzo Da Ponte, Mozart's librettist, arrived in New York and reunited with family members living on Bayard Street and the Bowery. He became the first professor of Italian at Columbia in 1825 and was an indefatigable promoter of Italian language and culture, even into his nineties, from his home, a virtual Italian cultural center. In 1832, he brought the first professional opera company to New York.

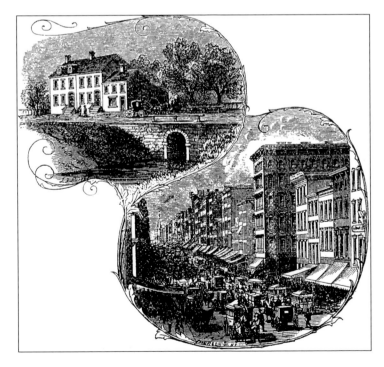

By 1819, Da Ponte resided at Provost and Chapel Streets, near today's West Broadway. Nearby was this view of the 1812 depiction of Canal Street's Stone Bridge Tavern and Garden (left). Canal Street was so named because it was a small stream that served as an egress from the Collect pond to the Hudson River. The stone bridge afforded a crossing at Broadway. The radically different scene (right) is from 1876, when Italians began arriving.

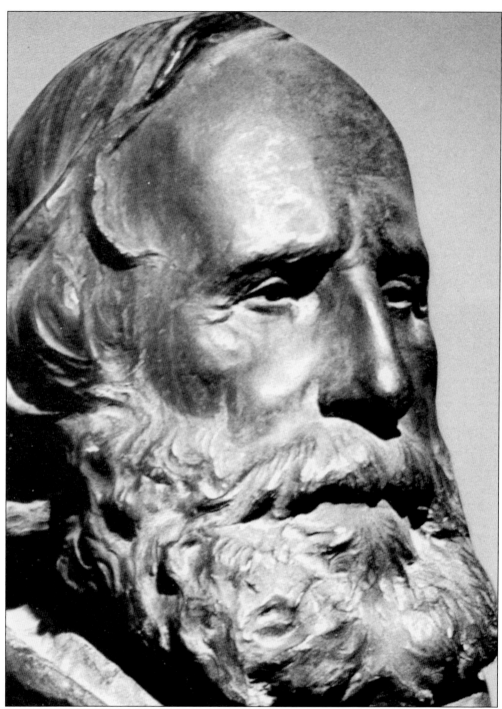

Another celebrated Italian immigrant to New York City was Giuseppe Garibaldi, the great Italian Liberator, who arrived in New York City as a refugee in 1850, after the collapse of the Roman Republic. In Little Italy, a "national" holiday was celebrated every year on September 20, the date commemorating Garibaldi's triumphal march into Rome, securing the capitulation of the Vatican Territory and the unification of Italy.

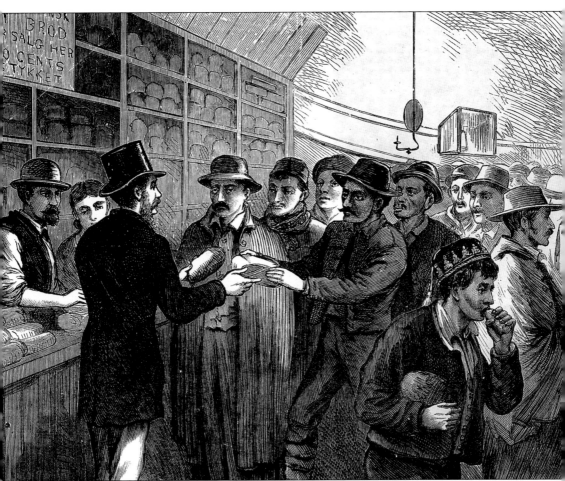

Castle Garden, the former Castle Clinton fort, was later used as a music hall, where the famous singer Jenny Lind, the "Swedish Nightingale," performed. As immigration swelled, Castle Garden was pressed into service as New York City's early immigrant processing center. This 1872 drawing shows an agent distributing bread to Italian immigrants who had been defrauded.

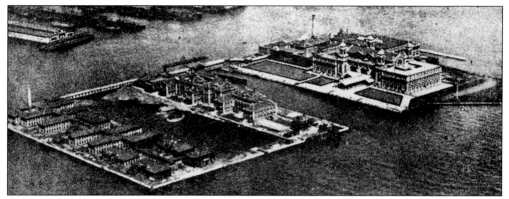

The Italian press called Ellis Island *"L'Isola degli Immigranti,"* or the immigrants' island. In 1892, it took over the duties once performed by Castle Garden; in addition, it had dormitory, hospital, and quarantine buildings. The Society for the Protection of Italian Immigrants had agents on the premises to assist the newly arrived immigrants, helping them with documents and sometimes escorting them from Ellis Island to their destinations in Little Italy.

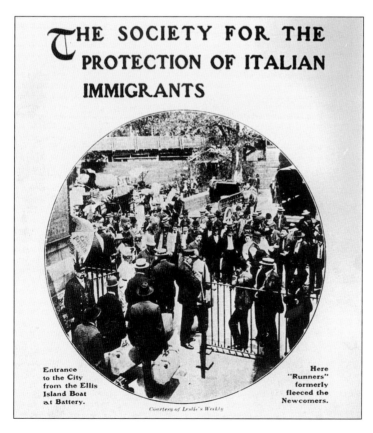

THE SOCIETY FOR THE PROTECTION OF ITALIAN IMMIGRANTS

Entrance to the City from the Ellis Island Boat at Battery.

Here "Runners" formerly fleeced the Newcomers.

Courtesy of Leslie's Weekly

This booklet was published in 1901 by the Society for the Protection of Italian Immigrants, originally located at 17 Pearl Street. The society is where newcomers went for advice on jobs, housing, or transportation. In 1903, it moved to 159 Mulberry Street, between Hester Street and Grand Street, where, by 1912, the society also had a chapel. This branch remained in operation for only another year.

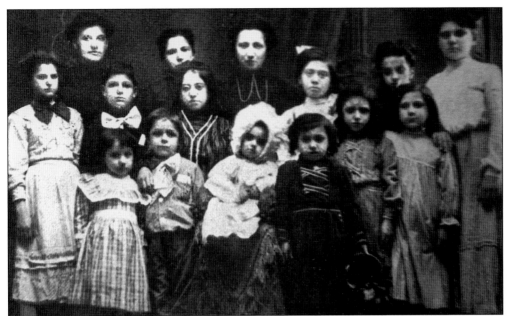

These Italian immigrant women and children (above) were residents of St. Raphael's Home for Italian Immigrants (below). They are shown *c.* 1905, most probably awaiting the arrival of relatives. The Scalabrinians, the Missionaries of St. Charles Borromeo, founded the St. Raphael Society for the Protection of the Italian Immigrants of New York in 1891 and maintained it until 1923. The society, which was subsidized by the Italian government, outlined its aims in its first annual report, in 1892: to assist the newly arrived, lest they fall into dishonest hands, and to help them find work; to administer religious assistance; to maintain a home in which young boys and girls could reside until claimed by relatives. The Sisters of Charity Pallottine were also active with the society.

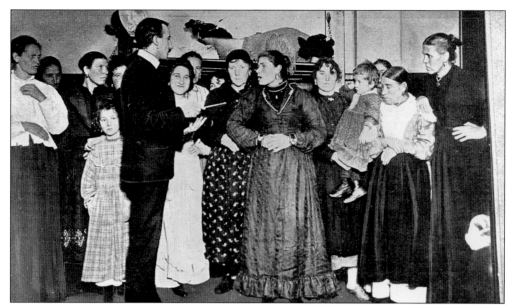

An agent from the Society for the Protection of Italian Immigrants listens to recently arrived immigrant women in the women's waiting room at the Ellis Island Immigration Station in 1901. The agents of the society were able to serve as interpreters, help immigrants connect with relatives, help get them to final destinations, and ease the transition from steerage to Little Italy.

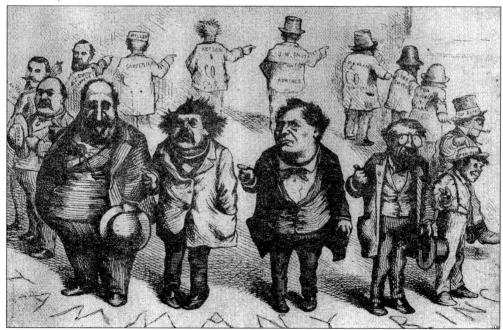

Early immigrants of the 1860s and 1870s found a city, and particularly Five Points, controlled by the corrupt William Marcy "Boss" Tweed, the political head of the "Ring," as illustrated in this famous Thomas Nast caricature from *Harper's Weekly*. Supported by the corrupt Tammany Hall, Tweed was notorious for embezzling millions of dollars, especially during construction of the courthouse at 52 Chambers Street.

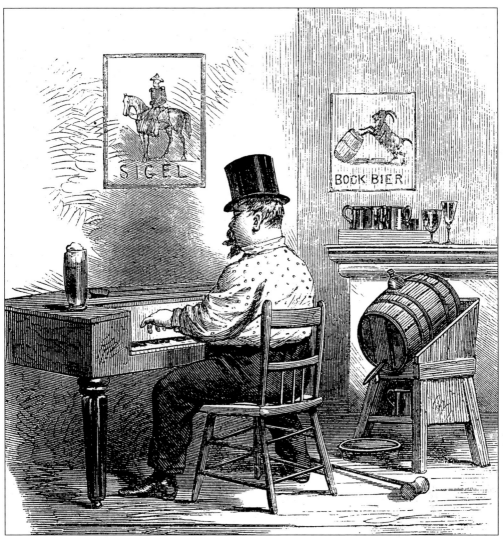

Another common sight Italians found in Five Points was the German beer garden, complete with signs reading "Lager Bier . . . Grosses Concert . . . Eintritt frei," barrels of beer, and lively music. The Volksgarten Beer Hall and the German Opera House were on the Bowery at Bayard Street. In 1859, the "German block" was the east side of Mott Street between Canal and Pell Streets. The German Mutual Benefit Society was at 136 Canal Street.

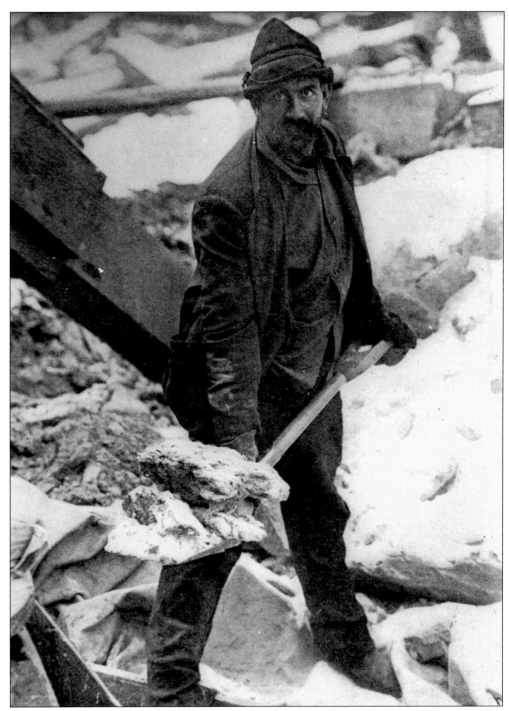

This typical image of an unskilled laborer wielding a shovel full of rocks represents the occupation of thousands of early Italian immigrants who worked building the subways and railroads, in mines and on roadways, and in factories. They were usually underpaid and exploited by both Americans and Italian *padroni* yet still saved enough money to have made the voyage worthwhile, to return home, and do the whole thing all over again another year.

Two

COMMUNITY

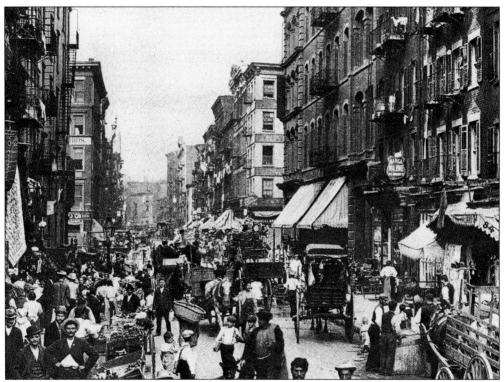

Most immigrants chose to settle together in the larger cities on the eastern seaboard. This picture, taken at a point just north of the famous "bend" in Mulberry Street, vividly encapsulates a point in time in the Italian ghetto. Since so many new entries were unskilled laborers, illiterate in English if not in formal Italian (many spoke only a regional dialect), the industrial East was an inevitable attraction. The greatest concentration of Italians continued to be in New York City. The 1900 census showed that 225,026 Italians lived in New York City alone.

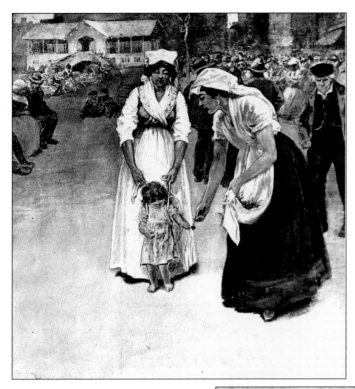

Mulberry Park was constructed in 1897, after the notorious slum block of Mulberry Bend between Bayard and Park Streets with its slums, raucous bars, and dance houses had been torn down through the efforts of Jacob Riis. The women, wearing traditional costume in this 1897 picture from *Harper's Weekly*, seem to be enjoying the communal ambience of the new park. The newspaper is really editorializing on the removal of the slum.

Fiorello La Guardia, mayor of New York City from 1933 to 1945, was affectionately known as the "Little Flower." While still in law school, he was an interpreter for Italian immigrants at Ellis Island. After his election, La Guardia found a statue of Columbus stored in the basement of city hall. He decided to install the statue in Mulberry Street Park and to rename the park Columbus Park.

Not all Italian immigrant children were barefoot orphans and street musicians. These two preschool boys, Alfredo and Armando Campomenosi, enjoyed the success of their father's artificial flower factory. Their father, Pietro Campomenosi, was born in 1868 in Santostefano Val d'Aveto, Liguria. He came to the United States in 1884 and went into artificial flower manufacturing at 136 Bleecker Street. He later relocated to 542–544 West Broadway, where he employed 25 men and 175 women, all Italians.

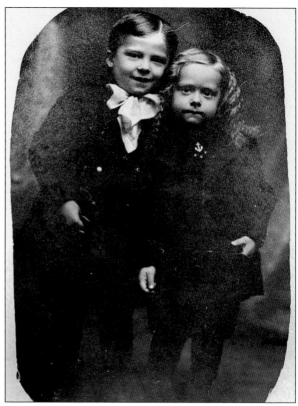

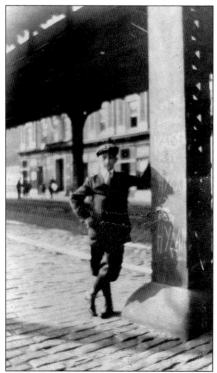

Young Joseph La Barbera stands proudly on the cobblestone street under the Third Avenue Elevated train in 1919. The picture predicts the future, as the fast, easy, and inexpensive mode of transportation permitted more and more working-class immigrants and laborers to live away from the city's congestion and still travel to work in the downtown industrial areas. La Barbera moved to the Bronx; unfortunately, he died at the age of 28.

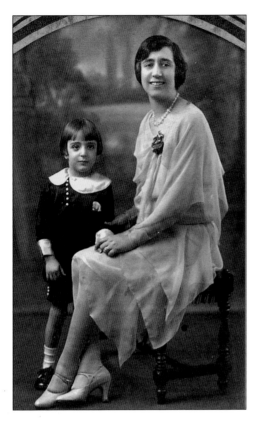

These members of the La Barbera family lived on Elizabeth Street when Maria "Marietta" La Barbera (left, with her son Joseph) arrived in New York City in 1910 at age 15 from Villafrate, on the outskirts of Palermo. Marietta's mother, Domenica (below, holding a grandchild in 1919), arrived in 1914. Maria married barbershop supplier Joseph Ligammari and moved with him to Chicago. When he died in 1924, just before the birth of their son Joseph, she returned to New York City. She remarried longshoreman Ciro Nasti and had a daughter, Concetta "Jean," but Nasti died in 1929. She was married a third and last time to Santo Grasso in 1938. Marietta also worked, doing beading for dresses.

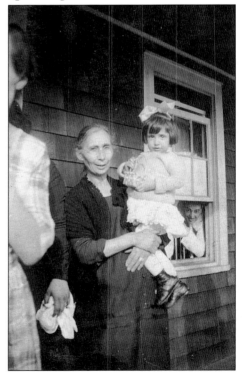

Giuseppe Mazzini was a champion of religious freedom and a unified Italy. The Italian community in New York in the early 19th century was mostly made up of northern Italian political and religious refugees. Their combined societies organized funding for the Mazzini bronze bust, sculpted by Giovanni Turini. The bust was installed in Central Park in 1876. Turini also sculpted the statue of the other champion of the republic, Giuseppe Garibaldi, now in Washington Square Park.

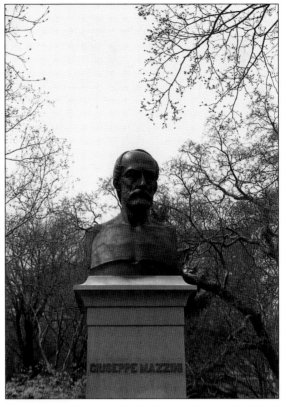

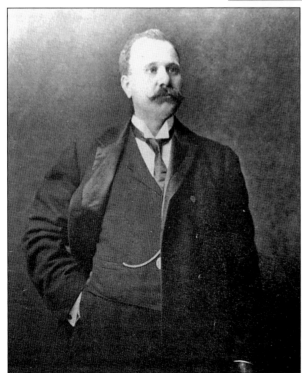

The community was woven together socially by fraternal, benevolent, and philanthropic associations headed by Italian businessmen. Vito Contessa, born in 1860 in Atella, Basilicata, immigrated to the United States in 1885, worked in construction, and became active in Democratic politics and Italian philanthropic organizations. He was an officer in the Italian Savings Bank, at 62-68 Spring Street, which opened in 1896. President of the Sons of Columbus Legion, he produced benefits for community concerns, including the Italian Benevolent Institute.

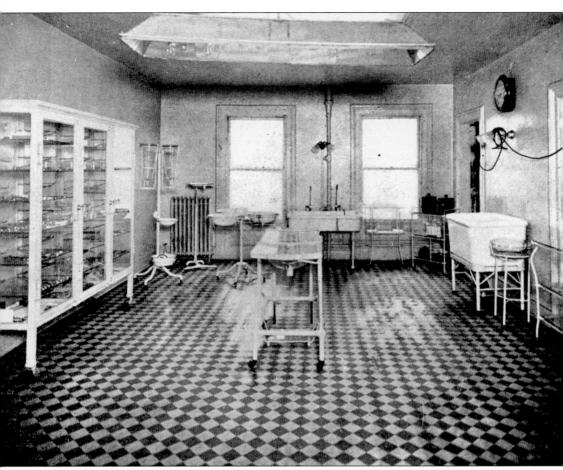

Relocation from a rural environment to congested tenements left many immigrants susceptible to tuberculosis. The "Lung Block," between Market Slip and Catherine, Cherry, and Hamilton Streets, was home to 404 tubercular cases c. 1906. The Italian Benevolent Institute was concerned with the health and welfare of Italian immigrants in Little Italy. Nurses and doctors staffed the institute's health facility. M. Caturani, M.D., who received his medical degree in Naples in 1899, directed the gynecological clinic c. 1906. The operating room is shown above. The institute was founded in 1857 at 7 Broadway; it incorporated in 1885, and its first building opened in 1888 at 20 Varick Place. It relocated to 27 Hancock Street in 1901 and then to 165–167 West Houston Street in 1902. There, it consisted of three five-story buildings. Little Italy's philanthropists supported the institute and sponsored fund-raising benefits. In 1908, the president of the society was Rev. John M. Farley, archbishop of New York; its director was Rev. Dr. Gherardo Ferrante.

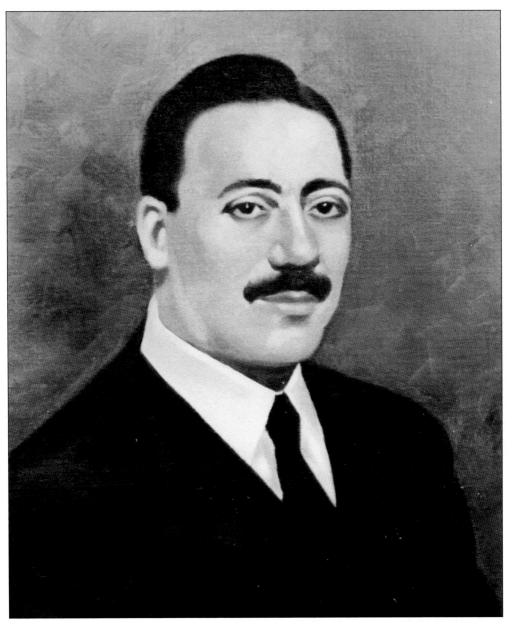

The Order Sons of Italy in America (OSIA) was founded on June 22, 1905, by Dr. Vincenzo Sellaro (1868–1932) at his office and *scuola per levatrici* (midwifery school) at 203 Grand Street. The group was then called Figli d'Italia in America. Dr. Sellaro was aided by pharmacist Ludovico Ferrari, lawyer Antonio Marzullo, sculptor Giuseppe Carlino, barbers Pietro Viscardi and Roberto Merlo, and Dr. Vincenzo Buffa, obstetric surgeon at 28 Stanton Street. Born in Polizzi, Generosa, Sicily, Sellaro received his medical degree from the University of Naples in 1895 and came to New York in 1897.

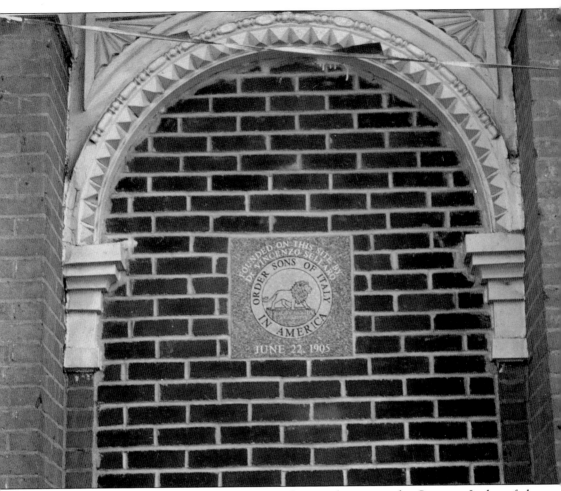

The Order of the Sons of Italy in America became known as the Supreme Lodge of the Sons of Italy. The plaque (above) installed on Grand Street commemorates the site and date for posterity. The order's purpose was to unite under one organization the many societies of Italian immigrants in America and to provide encouragement, education, and resources for its members.

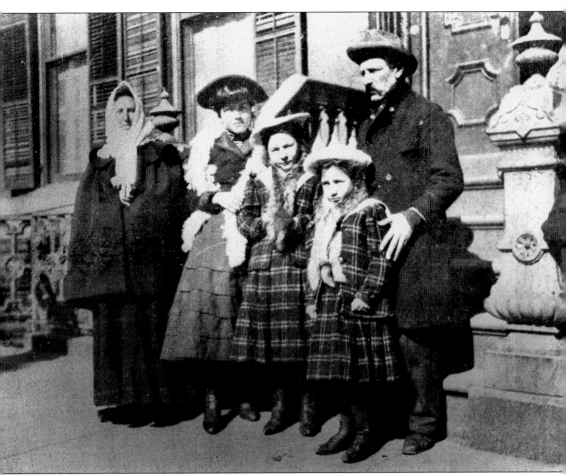

These survivors of the December 28, 1908 earthquake in Messina, Sicily, were assisted by the St. Raphael Society for the Protection of Italian Immigrants in 1909. The earthquake left families such as this one homeless and the Italian government helpless. The family members were father Pasquale Lango, age 50; mother Giuseppa Battaglia, age 48; daughters Nunzia, age 14, Salvatrice, age 10, and Petrina, age 9. The society housed the family in its hospice while arranging to reunite the family with a relative.

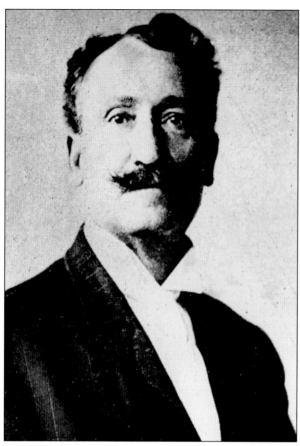

In addition to the benevolent associations, another unifying social factor for the Little Italy immigrant community was the Italian-American press, in which businesses were advertised, social events were announced, the daily life of the neighborhood was narrated, and events in Italy were reported. In 1880, Carlo Barsotti founded one of the best-known Italian-American newspapers, *Il Progresso Italo-Americano* (*Italian-American Progress*), at 42 Elm Street, which remained in existence until the late 20th century. He was the editor as well as publisher of the newspaper. After being knighted by the Italian government for his work with the newspaper and for promoting the splendor of Italy, particularly his campaigns to erect statues of Italian heroes, his title became *"Cav. Uff." (Cavaliere Ufficiale)*. In 1946, after the war, *Il Progresso* also launched the fund-raising Campaign for Italian Relief.

IL PROGRESSO ITALO-AMERICANO

ESTABLISHED - 1880

MEMBER:
AMERICAN NEWSPAPER PUBLISHERS
ASSOCIATION
AUDIT BUREAU OF CIRCULATIONS

CAV. UFF. CARLO BARSOTTI
PUBLISHER AND EDITOR
42 ELM STREET
NEW YORK

CABLE ADDRESS
AIRDRUM, NEW Y
PHONES:
FRANKLIN 2370 - 237

ALL CORRESPONDENCE MUST BE ADDRESSED TO THE FIRM

The 75-foot monument to Christopher Columbus, located at Columbus Circle, was sculpted by the Sicilian Gaetano Russo. The sculpted body of Columbus is 26 feet high and made of Carrara marble. The four-sided pedestal displays a winged youth with a globe, an allegory of discovery, and Columbus's three ships; the column has six ship prows. The monument was financed by the Italians through Barsotti's nationwide *Il Progresso* campaign. Local Italian-American organizations also raised considerable amounts of money. Local community groups, including the young students of the Teodoro Palumbo School, at 54 Prince Street, held benefits and fund-raisers between 1889 and 1890. The monument was unveiled and dedicated on October 12, 1892, the quadricentennial of Columbus's discovery of America. Some 10,000 people were in attendance, including representatives of Spain and Italy. The ceremony included speeches, water displays, military exercises, and dance performances.

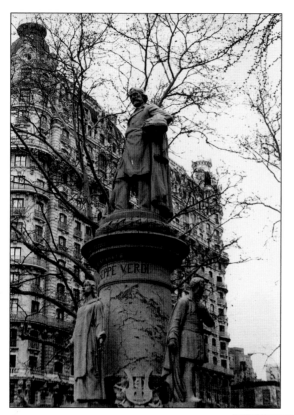

In 1901, Carlo Barsotti launched another national *Il Progresso* campaign for a monument as a memorial for opera composer Giuseppe Verdi, who had just died. Pasquale Civiletti sculpted the statue of white Carrara marble. Verdi is kept company by leading characters of his operas: Othello, Leonora, Falstaff, and Aida. The memorial is situated across from the Ansonia Hotel (background), in the heart of what was once a neighborhood where musicians and singers lived, practiced, and worked.

The fifth *Il Progresso* subscription campaign was for a monument to Dante Alighieri, writer of *The Divine Comedy*. It was launched by Carlo Barsotti in 1912 as a celebration of Italy's 30 years as a unified nation. Little Italy, however, suspected that Barsotti had less patriotic than ambitious intentions. Nevertheless, the money was raised and the statue went up, albeit nine years later in 1921, by then celebrating the 600th anniversary of Dante's death.

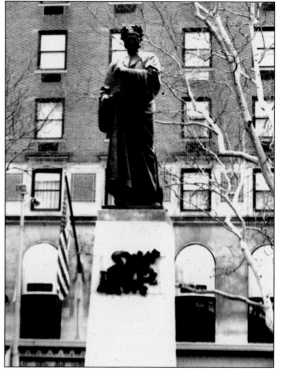

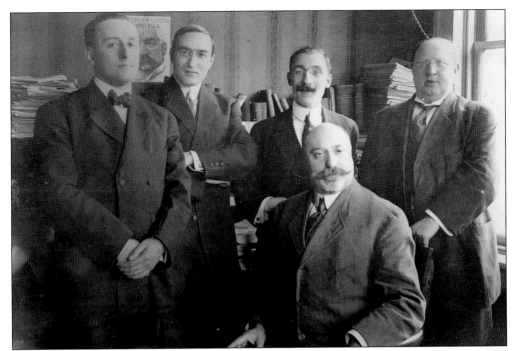

Agostino De Biasi and his four-man staff are shown at *Il Progresso Italo-Americano*, at 42 Elm Street. De Biasi was editor-in-chief from 1900 to 1911. His younger brother, Carlo (1896–1975), was also in publishing. He managed the Brooklyn Italian Catholic weekly *Il Crociato* (the *Crusader*) from 1933 until his retirement in 1963.

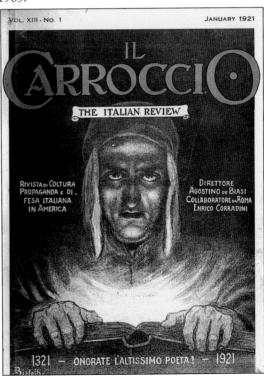

Agostino De Biasi started the Il Carrocio Publishing Company in 1915, at 150 Nassau Street. He produced the monthly journal *Il Carrocio* (*Italian Review*), which did features and advertising on all the businesses, banks, and personalities of Little Italy. The cover of this 1921 edition has a picture of Dante, most probably to coincide with the Dante statue dedicated that year. Several articles about Dante appeared within.

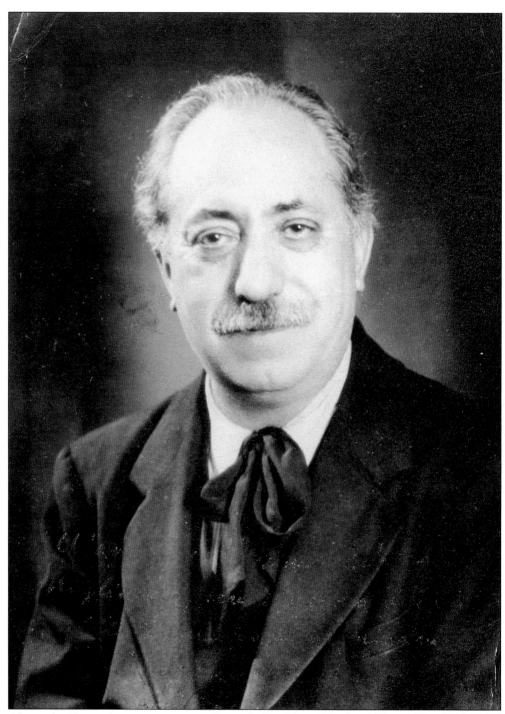

Alessandro Sisca, whose pen name was Riccardo Cordiferro ("Richard Heart of Iron"), founded the literary newspaper *La Follia* in January 1893 with his father and his brother, Marziale. The newspaper's offices were at 151 Mott Street, 202 Grand Street, and eventually 226 Lafayette Street. The paper was widely read. His literary articles and political commentary usually expounded socialist doctrine and earned him the title "Singer of the Red Muse."

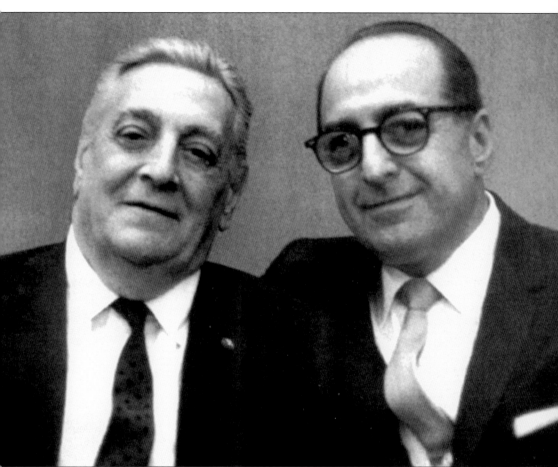

Michael Sisca (right), shown with his friend Tito Schipa, a tenor, was the nephew of Cordiferro and son of Marziale Sisca. After Marziale's death in 1965, he continued to publish *La Follia*, with offices at 511 Canal Street, until his death in 1997 at the age of 93. He was a friend of Enrico Caruso and a devotee of opera. *La Follia* published Caruso's many caricatures of famous people, including Little Italy figures.

Dr. Luigi Pane was born in 1867 in Torre del Greco. He was the editor of *Piedigrotta*, a magazine commemorating the Neapolitan songfest at 109 Mulberry Street in 1907. This event brought out the whole of Little Italy, and the magazine reads like a profile of the community. The full title of the publication was *Piedigrotta alla Villa Vittorio Emanuele III*. Pane was also editor of *Il Corriere Vesuviano* (*Courier of Vesuvius*).

Dr. Oreste Fermariello was an award-winning writer and impassioned dialect poet, described as "erudite and talented" by editor Luigi Pane in the *Piedigrotta* souvenir magazine. Because he was so highly respected, Fermariello served as a member of the 1907 Piedigrotta examining committee with other distinguished writers and poets of Little Italy.

The artist and interior designer Gaetano Sorrentino was born in 1869 in Naples, where he studied at L'Istituto delle Belle Arti (Institute of Fine Arts). Arriving in New York in 1907, he was commissioned to redesign the interior of the Villa Vittorio Emanuele III, at 109 Mulberry Street, just months before the September festival; he also created the cover design for the souvenir program.

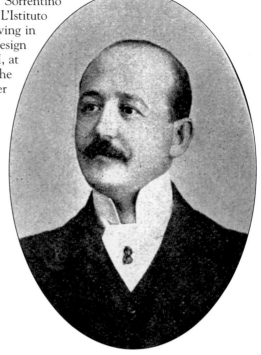

Raffaello Beraglia owned the Beraglia Press, at 169 Mulberry Street, between Grand and Broome Streets. He printed not only the *Piedigrotta* souvenir magazine at no charge for the community but also various other literary works. He was partner and proprietor with A. Palmieri of Sala Elena, a billiard and event hall at 381 Broome Street, between Mott and Mulberry Streets. G.A. Megna was the manager.

The Emporium Press, the "Italian Printing Establishment" at 105–111 Wooster Street, between Spring and Prince Streets, did all kinds of printing and publishing for the community. Run by the De Biasi publishing family, it promised excellent paper, modern face type, careful service, and fair prices. The company maintained that it could compete with the best American printing houses.

36

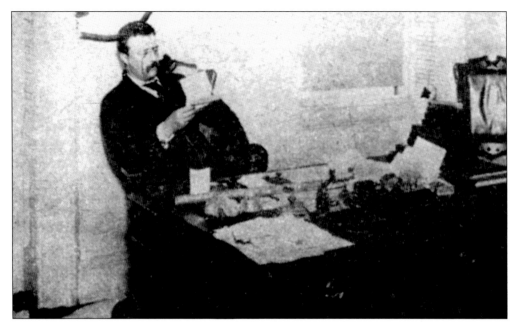

In 1895, Mayor William Strong appointed Theodore Roosevelt as president of the New York City Police Board. His stated purpose was to "assure an honest and efficient police force." Roosevelt had his offices in the 300 Mulberry Street building. During his tenure on the board, he received praise for fairness and administration. He left two years later to serve as assistant secretary of the navy for Pres. William McKinley.

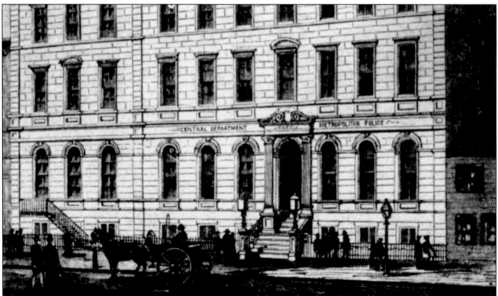

Little Italy's famous police precinct was located at 300 Mulberry Street, between Houston and Bleecker Streets—the Old New York Police Headquarters building, home to neighborhood cop Joseph Petrosino. The four-story stone structure, designed by Thomas Little, housed the new Metropolitan Police District from 1863 to 1909. The building also served as the Magistrates Court from 1910, the Traffic Court, the Property Clerk's Office, and, until 1961, as the Home Term Court.

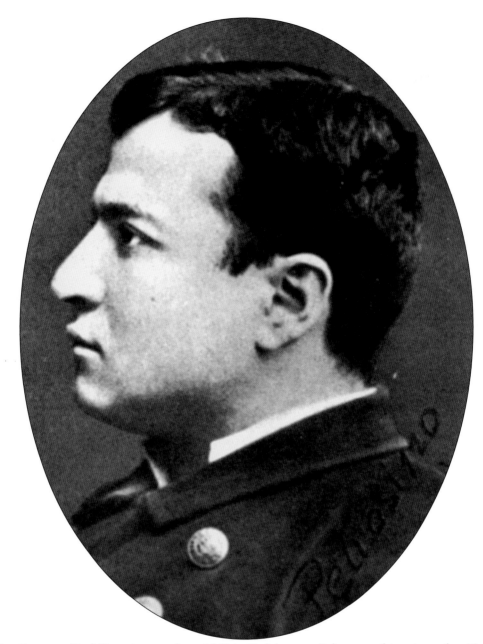

Lt. Giuseppe "Joe" Petrosino was born 1860 in Padula, near Salerno, and immigrated to New York in 1873. He lived across from Kenmare Square Park (now Petrosino Park) at Lafayette Street and Cleveland Place. In 1883, he enlisted in the New York Police Department. He was made sergeant in 1895 with Roosevelt's recommendation. His skills included undercover disguises and a knowledge of Italian dialects, all of which facilitated his campaign against the Black Hand, the organized crime of the period. He was called the "Detective in the Derby." He always wore his signature derby, as well as double-soled shoes to camouflage his short, five-foot, three-inch frame. In 1905, when he was made lieutenant, he was put in command of the Italian Legion, organized specifically to combat organized crime. Some 500 gangsters were reputedly jailed through the legion's work.

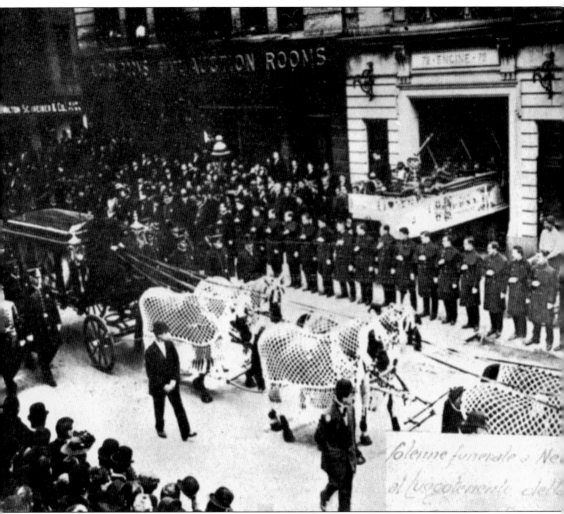

Joe Petrosino's ability with dialects helped him gather enough intelligence to believe that Italian crime in the city had its roots in Sicily. He decided to go there to conduct an undercover investigation of the Black Hand. However, in March 1909, he was shot and killed by a gunman as he walked near a statue of Garibaldi at Piazza Marina in downtown Palermo. After the murder, Petrosino's body was brought back to New York. His funeral procession in Little Italy, led by a hearse drawn by six horses, was attended by 250,000 people, crowding the neighborhood streets. Kenmare Square Park, at Lafayette Street and Kenmare Place, across from his home, was named after the brave policeman. An Italian ballad was written telling the story of his life and death. After his murder, the leadership of the Italian squad went to "Treat 'em Rough" Mike Fiaschetti, who reportedly sent 100 men to the electric chair.

American-born attorney Giulia Grilli was an early Italian-American feminist of the community. She was one of the founders of the Order of Women Lawyers and initiated an action in the state of New York to permit women to serve on juries. She was supported in 1921 by the Women's Democratic Club for a judgeship. Her father, Cav. Nicola Grilli, was from Sulmona, Abruzzi.

The CONTESSA OF MULBERRY STREET

by N. D. BELLITTO

PRODUCTION BY GENE FRANKEL

GENE FRANKEL THEATRE
342 East, 63rd Street, N.Y.C.,
Call: 421-1666 for information.

For many immigrants, Mulberry Street was all they knew of America. For others, Mulberry Street *was* Little Italy, and now more than ever. The street has inspired paintings, novels, plays, poetry, and movies, all attempting to re-create the nostalgia of a period when women in long skirts and men in caps and derbies negotiated the pushcarts and streets in the daily commerce of their lives. The play, *The Contessa of Mulberry Street*, was written in English in the 1960s by N.D. Belitto. The off-Broadway production was described by the press as a "slice-of-life memory play" about New York's Italian-Americans. The plot revolves around missed furniture payments, gambling debts, and young love. With these melodramatic touches, it is not too far removed from Bernardino Ciambelli's *The Foundling of Mulberry Street*, of 1898.

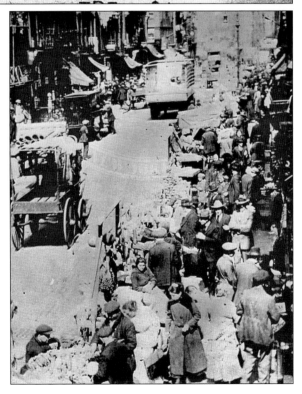

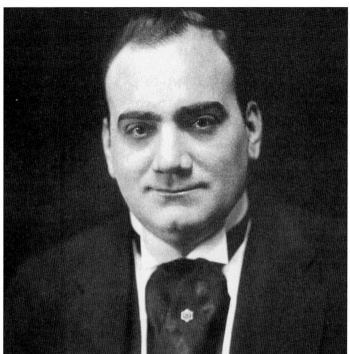

Little Italy has always drawn celebrities, and Enrico Caruso was one of the earliest. His friendships in Little Italy included the Sisca family and banker Angelo Legniti of Mulberry Street and entertainers in Little Italy's music halls and nightclubs, such as Farfariello and Guglielmo Ricciardi, whose shows Caruso always enjoyed.

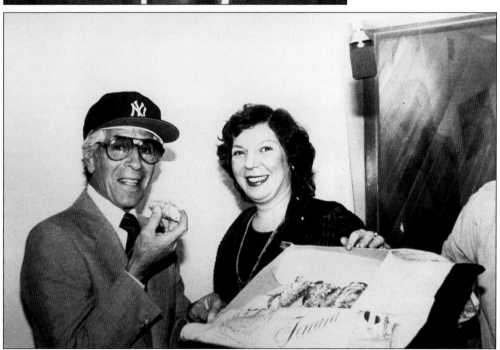

Baseball legend Phil Rizzuto, the "Little Scooter," enjoys a cannoli with Anna Maria Lepore of Ferrara's. Rizzuto was the voice of the "Holy Cannoli" radio advertising campaign, which Lepore organized for the famous *pasticceria*. It promised "Heaven in the Heart of Little Italy." The Lepore family business is now in its fourth generation from the original *caffe* started in 1892.

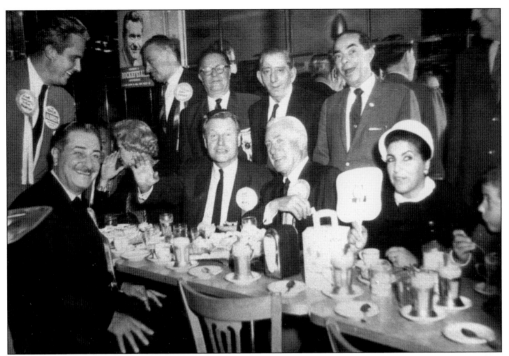

Little Italy is always a stop for politicians seeking votes. In the 1960s, Nelson Rockefeller (seated, with his hand raised) and supporters stop for dessert during his election campaign. Wearing a white hat and holding a campaign fan is Licia Albanese, then a diva of the Metropolitan Opera. In addition to her appearances at the Met and her concert tours, she also sang on radio. Arturo Toscanini selected her to be the soprano star for his annual Gala Operatic Broadcast. She recorded on Victor records. Today, she heads the Puccini Foundation. Standing behind her is Pietro Lepore, then owner of Ferrara's.

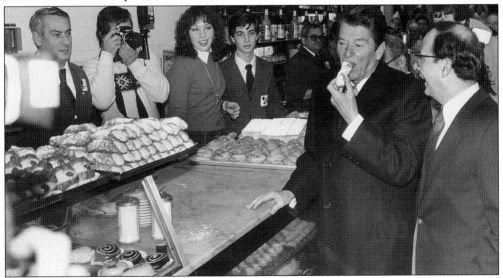

Alphonse D'Amato (right) looks on as Ronald Reagan samples a cannoli. Behind the counter, family member Edward Scoppa III photographs Reagan while, to his left, cousins Louise Lepore and Ernest Lepore watch.

This building on Mulberry Street was built in 1926 by the father of John Esposito, whose meat market was on the first floor of a tenement across the street. Dedicated to Anna Esposito, the building is a memorial to a woman's life played out in Little Italy.

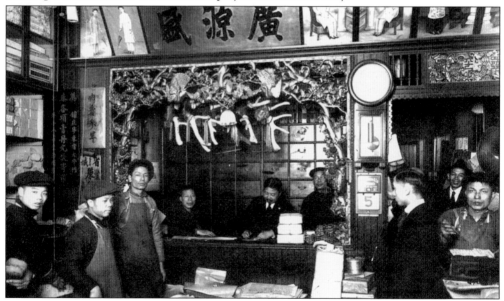

In 1855, German families occupied the future Chinatown, Mott Street below Canal. By 1880, what had once been 12 Chinese residents in the area in 1872 had swelled to 700. Tom Lee, the "Great Mongolian Magnate" of 16–18 Mott Street, established the first Chinese mutual aid society, Loon Ye Tong. Pictured is a Chinese store c. 1900. Virtually all Chinese now is the once former Little Italy above and below Canal Street, except for Mulberry and its intersections.

Three

RELIGION

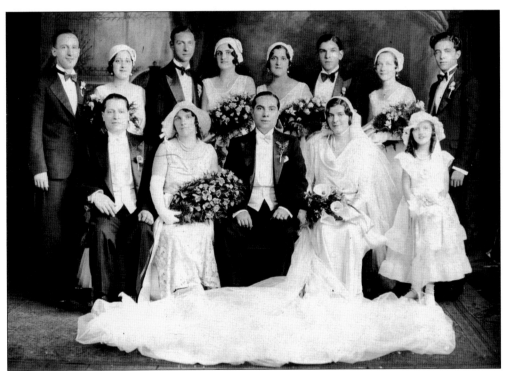

Matrimony is one of the seven sacraments in the liturgy of Roman Catholicism, the faith most Italians in Little Italy professed. On July 3, 1932, the wedding of Pietro Lepore and Eleanor "Ida" Scoppa (seated, third and fourth from left) was celebrated at Old St. Patrick's Church, at Mott and Prince Streets. Standing behind the bride and groom, from center to far right, are Marcia Scoppa, Ettore "Willie" Scoppa, Elisa Bellincampi, and her future husband, Philip Scoppa. Both Lepore, who was Antonio Ferrara's nephew, and the Scoppa brothers, Enrico and Eduardo, had a working interest in the Caffe Ferrara at 195 Grand Street. This marital union resulted in four generations operating a family-run enterprise, which still operates today.

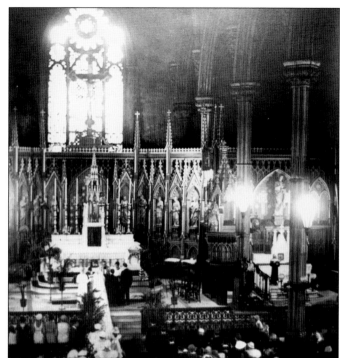

The Lepore-Scoppa marriage was solemnized at St. Patrick's main altar. Domenico Borgia sculpted the central statue of Jean Baptiste de la Salle, founder of the Brothers of the Christian Schools. First dedicated in 1815, the church was destroyed by fire in 1866. Rebuilt and rededicated in 1868, St. Patrick's continued to serve as New York's first Roman Catholic cathedral until 1879, when the new St. Patrick's on 5th Avenue was completed.

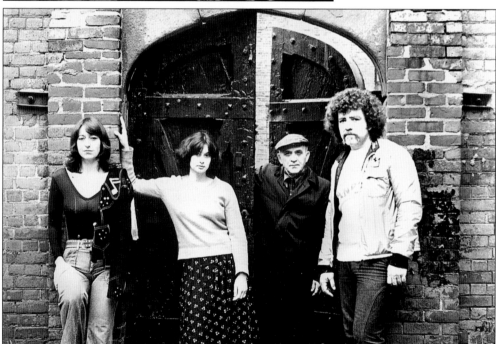

The interior of St. Patrick's cemetery is accessed through these huge iron gates. Among the many New Yorkers buried at the cemetery are Stephen Jumel, the noted merchant; Andrew Morris, the first Roman Catholic elected to public office in New York; Pierre Toussaint, the freed Haitian slave and candidate for sainthood; and Mother Elizabeth Seton. Pictured at the gate are the producers of a show at St. Patrick's about Italian immigrants.

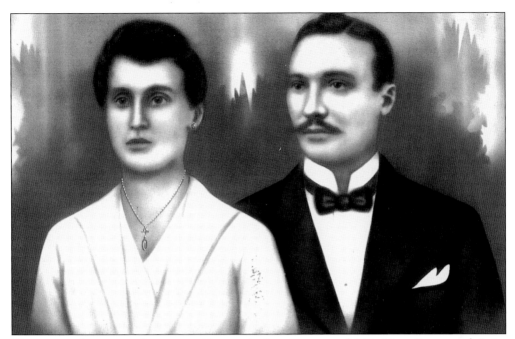

The arranged marriage between widower Andrea Camera of 291 Mott Street and Luisa Gambardella of 211 Mott Street took place at the Church of Our Lady of Loreto, at 303 Elizabeth Street, on February 13, 1894, five days after Luisa arrived in New York on the ship *Massilia*. Camera, originally from Amalfi, was a professor of music, a composer, and a bandleader who conducted at concerts in and around Little Italy.

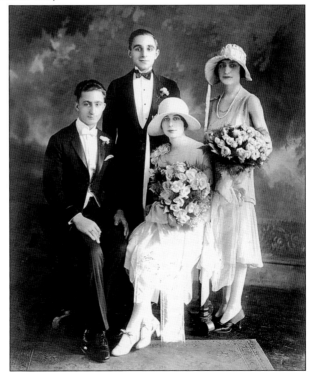

The La Barberas of Elizabeth Street celebrated this 1923 wedding of Frank La Barbera to Edna, a young woman of German descent. The witnesses were Celestina La Barbera, Frank's sister, and Joseph Castrogiovanni, who later married Celestina. Frank La Barbera maintained a store in which he sold *salumeria* and mozzarella.

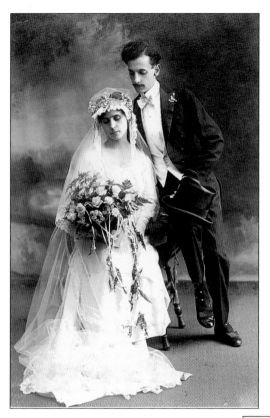

Not all Catholic couples married in church. This wedding between Vladimiro Lutterotti and Emma Albertini took place at the nearby municipal building, on Centre Street, on June 30, 1917. Albertini had sailed from Genoa and first arrived in New York, where she worked as an embroiderer, in 1899; Lutterotti, an artist and designer from Riva, Cremona, arrived in 1913. He died during the 1919 influenza epidemic.

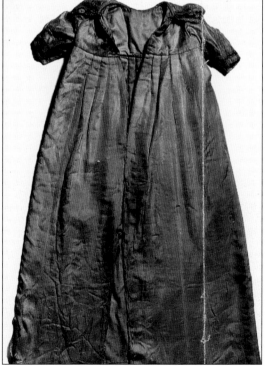

The rite of baptism is the first sacrament a Catholic receives, the prerequisite before being allowed to receive any of the six others. The oversized baptismal gown was the traditional costume for the newborn infant, whether male or female, who was about to be initiated into the Roman Catholic faith.

First Holy Communion is the second sacrament to be received, usually at the age of seven, when young boys and girls are considered to have reached the age of reason. After thorough catechism instruction and examination, the sacrament is administered collectively to all who are eligible. Girls look and dress like miniature brides in white dresses and short veils. In the days when street festivals were held, the girls wore this costume again; they were called *verginelle* (little virgins) and were actually suspended by the waist on high wires that arced the street, simulating the flight of angels. Concetta "Jean" Nasti (right), daughter of Marietta La Barbera and Ciro Nasti, makes her first communion, as does Anna Maria Lepore (below), daughter of Pietro Lepore and Ida Scoppa.

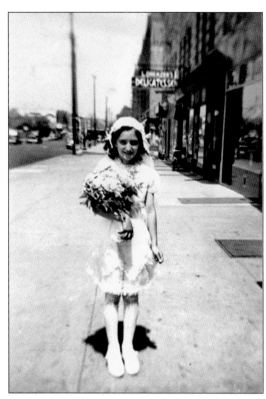

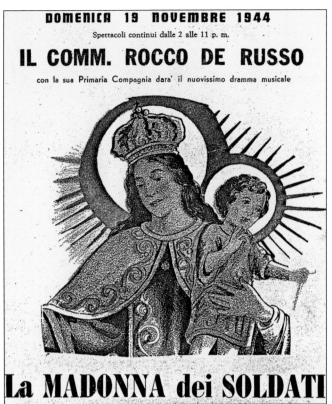

DOMENICA 19 NOVEMBRE 1944

Spettacoli continui dalle 2 alle 11 p. m.

IL COMM. ROCCO DE RUSSO

con la sua Primaria Compagnia dara' il nuovissimo dramma musicale

La MADONNA dei SOLDATI

Italians did not experience their religion only in
church. Recordings of sermons, plays, and hymns
were broadcast on the radio to the whole of Little
Italy. Church halls often hosted performances
of plays with religious and miraculous themes
to celebrate feast days and the major seasons of
the liturgical calendar and to reinforce the faith.
Theatre impresarios always knew such timely
melodramatic plays would bring in the audiences.
Above, *La Madonna dei Soldati* (*The Madonna of
the Soldiers*) was produced by Rocco De Russo in
1944. For Easter of 1938, Attilio Barbato directed
I Dieci Comandamenti (*The Ten Commandments*),
a religious radio drama by Carlo Garuffi, adapted
from the memoirs of G. Lo Presti. Some promised
scenes were "The Little Orphan of the Convent
of Holy Mary of the Angels" and "Angel
and Demon."

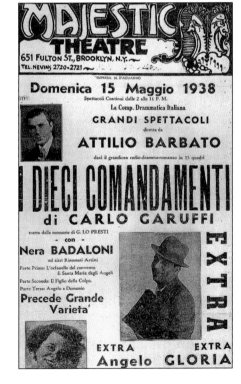

MAJESTIC
THEATRE
651 FULTON ST., BROOKLYN, N.Y.
TEL. NEVINS 2720-2721

IMPRESA M. D'AQUANNO

Domenica 15 Maggio 1938

Spettacoli Continui dalle 2 alle 11 P. M.

La Comp. Drammatica Italiana

GRANDI SPETTACOLI
diretta da

ATTILIO BARBATO

darà il grandioso radio-dramma-romanzo in 15 quadri

I DIECI COMANDAMENTI
di CARLO GARUFFI

tratto dalle memorie di G. LO PRESTI

- con -

Nera BADALONI
ed altri Rinomati Artisti

Parte Prima: L'orfanella del convento
di Santa Maria degli Angeli.

Parte Seconda: Il Figlio della Colpa.

Parte Terza: Angelo e Demonio.

Precede Grande
Varieta'

EXTRA

EXTRA EXTRA
Angelo GLORIA

St. James Roman Catholic Church was located at 32 James Street, at the corner of New Bowery (St. James Place), as early as 1876, when F.H. Farrelly was the pastor. Close by, at 22–24 Roosevelt Street, at James Street, was the parish of San Gioacchino (St. Joachim). A former Protestant church, it was opened by Scalabrinians in 1888.

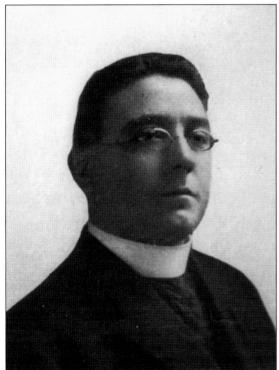

Fr. Vincenzo Yannuzzi was pastor of San Gioacchino in 1908. He was assisted by Rev. Fathers V. Cangiano, A.L. Strazzoni, and V. Cardinale. Yannuzzi was very active in strengthening the faith of his parishioners by establishing a mission for charity work among the Italians, including a school for teaching English classes. Some of the parish organizations were the Conference of St. Vincent de Paul, the Society of St. Joseph (for fathers of families), the Society of Christian Mothers, the Association of the Children of Mary (for young ladies), and the Society of St. Luigi Gonzaga (for young men).

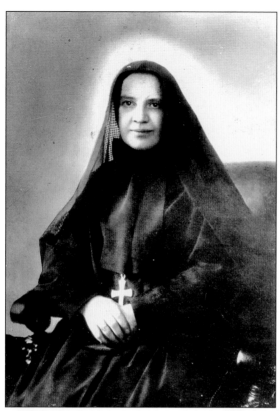

St. Frances Xavier Cabrini (1850–1917), "Saint of the Immigrants," was the first American to be canonized by the Church. Little Italy had special affection for her because, an immigrant herself in 1889, she lived and worked among them. A member of the Missionary Sisters of the Sacred Heart, she started Transfiguration School on Mott Street. Francesco Barilla and his wife would fill bags with candy from their store on East Houston Street for Mother Cabrini's children.

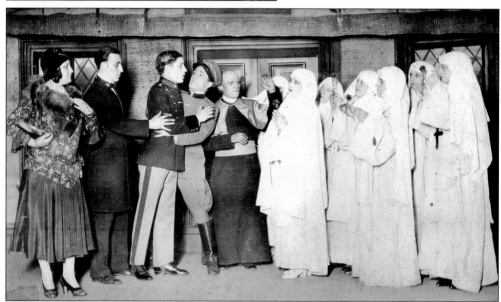

Devotion to Mother Cabrini inspired productions of radio broadcasts and plays about nuns, which were very popular. Clemente Giglio, who lived at 246 Elizabeth Street, directed *La Monaca Bianca (The Nun in White)* for radio and church halls; it starred his wife, his son Sandrino, actors Frank Masccetta, Gioacchino Magni, and Luigi Marmorino, and actress Stella Bruno.

Popular singer Rina Telli (right) starred as a nun in a musical production in which she sang hymns. In 1941, Marietta Maiori (below) played the role of Suora Celeste (Sister Celeste) in *La Preghiera di Pompei—La Canzone della Speranza* (*The Prayer of Pompei—The Song of Hope*). This "sensational drama of faith and sublime martyrdom," in a prologue and 10 acts, was one of the many plays with religious themes, written, performed, and directed by Orazio Cammi, on the *Lazzara* radio program and in the church halls of Little Italy.

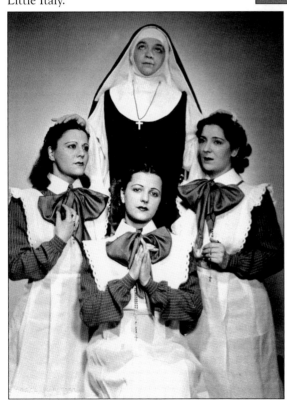

Rev. Ernesto Coppo of the Salesians of Don Giovanni Bosco arrived in New York in 1898 specifically to work with the growing numbers of Italian immigrants in Little Italy. In 1902, he became the rector of the Church of the Transfiguration and resided in the rectory, at 20 Mott Street. Coppo became president of St. Joseph's College in Troy, New York, in 1903.

A former Lutheran and then Episcopal church purchased by Archbishop John Hughes became the Catholic Church of the Transfiguration. A Georgian building with gothic windows, it was located on Mott Street at Park (the former Cross Street, and now Mosco Street). In 1878, Italians had to hear Mass in the basement; the regular American congregation excluded them from the main church. The rector then was James McGean. In 1889, the Scalabrinians established a mission for Italians in the basement.

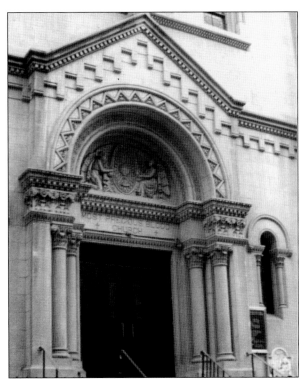

In 1888, services for the future *Chiesa del Preziossissima Sangue* (Church of the Most Precious Blood) first took place in a storefront on Centre Street (Rynders Street) until the church opened in 1890 on Baxter Street between Canal and Hester Streets by the Fathers of St. Charles Borromeo (Scalabrinians). In 1894, the Franciscan Brotherhood administered the Church. It was the first church to be built in Manhattan funded solely by Italians. A detailed bas-relief (above) illustrates the chalice of blood for which the church is named. Through these doors walked the popular actress Marietta Maiori when she married Attilio Giovanelli, the distinguished violinist and concert master, on Saturday, October 7, 1916.

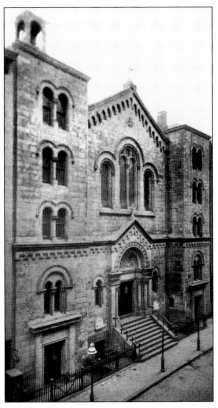

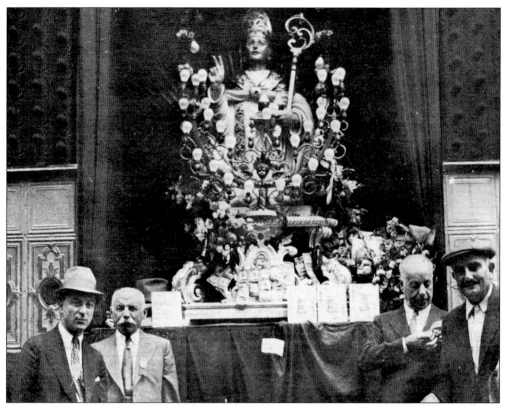

The San Gennaro Society (below) had headquarters at 165 Mulberry in 1895. Commendatore Antonio Ferrara stands in the center. The Church of the Most Precious Blood is the home of the national shrine of San Gennaro, the patron saint of Naples and Mulberry Street. The saint's feast day is celebrated on the streets of Little Italy for 11 days each September, during which an effigy (above) is carried in procession.

The feast St. Anthony of Padua, the saint of lost things, was celebrated in churches throughout the city. On Canal Street between the Bowery and Elizabeth Street, the oldest Church of St. Anthony was headed in 1859 by the Franciscan Father Sanguinetti. San Gioacchino's Church, at 22–24 Roosevelt Street, organized a St. Anthony parade in 1890. The radio play (below) *Il Miracolo di S. Antonio* (*The Miracle of St. Anthony*) was still being broadcast in 1979.

Grandi Festeggiamenti in onore di

S. ANTONIO DI PADOVA

Sotto gli auspici della Societa' S. Antonio fra i Giovinazzesi di New York e dintorni

CHE SI CELEBRERA' NEI GIORNI

24 - 25 - 26 GIUGNO 1960

in Mott, Hester e Grand Streets, New York City

PROGRAMMA

Illuminazione a cura della rinomata ditta ARNOLDO MIGLIACCIO e Figli da New York

VENERDI 24 GIUGNO

Ore 7.30 p. m. - Apertura della festa con la famosa NUOVA BANDA BAGNARA diretta dal valente Maestro VINCENT FEDELE, la quale allietera' il Rione Italiano di New York.

Ore 8 p. m. - Grande Mandolinata diretta dal Maestro Giuseppe Alagona con la partecipazione dei seguenti artisti:

MARIA ARGENTINA
SALVATORE PIROZZI
CATERINA CAPUTO
ANTONIO TERREZZA
LA SORRENTINA

Maestro di Cerimonie, Pasquale Cajano

SABATO 25 GIUGNO

Ore 10 a. m. - Giro nel Rione Italiano della Nuova Banda Bagnara.

Ore 10.30 a. m. - Nella Chiesa del Preziosissimo Sangue, 113 Baxter St., N. Y. sara' celebrata una Messa Solenne, con Panegirico, in onore di S. Antonio di Padova con la partecipazione di tutti i membri della Societa'

Ore 3 p. m. - Solenne Processione di S. Antonio con l'intervento di tutti i membri della Societa' e di molti fedeli devoti del Santo.

Ore 8 p. m. - Grande Mandolinata diretta dallo stesso Maestro e con la partecipazione dei seguenti artisti:

ROSA COSTANZA
AL CARR
I DUE MENESTRELLI
RITA BERTI

Maestro di Cerimonie, Pasquale Cajano

DOMENICA 26 GIUGNO

Ore 8 p. m.- La stessa orchestra come la sera precedente, con i sottoelencati differenti artisti: VIOLETTA DEI, LELLO CASTALDO
COSTANZA RINALDI
FEDERICO PICCIANO
RINA TELLI

Maestro di Cerimonie, Pasquale Cajano

COMITATO FESTA

Joe De Palo, *Presidente*
Nicola Mastropasqua, *Vice Presidente*
Frank Lazoras, *Sg. Finanza*
Domenico Torre, *Tesoriere*
Mariano Pierno, *Sg. Corrispondenza*
Tommaso Pappagallo Nicola Scivetti
Andrew Di Bari, *Cassiere*
Danny Fasle Vito D'Angelico
Jerry Scivetti, *Consigliere*

Alto Supremo Patrono
EMANUELE GIAMPALMO

Ospiti d'onore
Onorevole LOUIS DI SALVO
Avv. RALPH SANTORO
Avv. FRANK BLANGIARDO

Invitati d'Onore
Nicola Marcotrigiano Pietro Ferrara
Frank Iuculano

Soci Onorari
Arnoldo Migliaccio - Pat Zaffarese
Jimmy Vitale - Giovanni Sigismondi
Nicola Marcotrigiano

CONTADINI - Vi preghiamo fraternamente d'intervenire a questa bella e tradizionale festa.

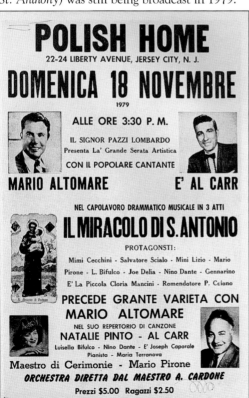

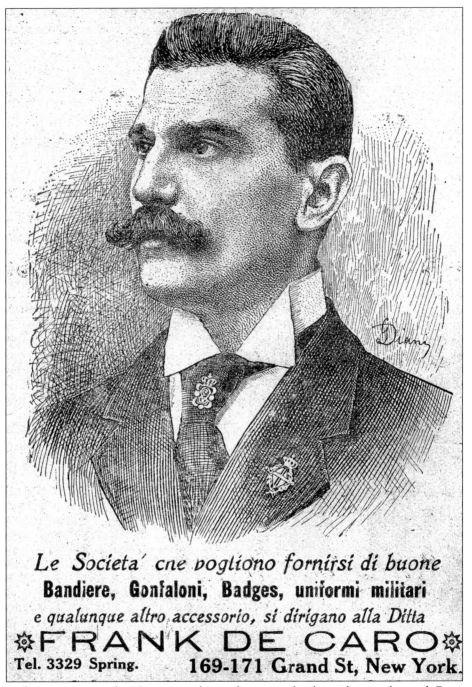

The advertisement reads: "Societies who wish to supply themselves with good Banners, Flags, Badges, military uniforms and whatever additional accessories, should look for the Sign ✳FRANK DE CARO✳ Tel. 3329 Spring. 169–171 Grand St, New York." Francesco De Caro specialized in making military uniforms resembling the grenadiers and cavalrymen of the Italian army. They were worn by the officers of the mutual benefit associations who marched in the feast day processions.

Confirmation is the Catholic sacrament that welcomes youth into adulthood, bringing with it the responsibility of leading an exemplary life, and defending and carrying on the Roman Catholic faith. Young Alfred Lepore, the son of Pietro Lepore and Ida Scoppa, makes his Confirmation at the age of 13.

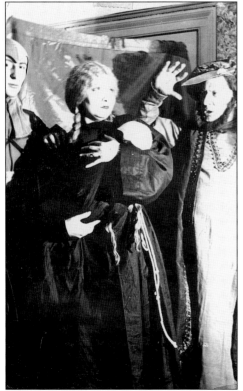

Actress Stella Bruno (center), the diva of the religious spectacle, starred again in the emotionally charged presentation for radio broadcast and live performance *Santa Genoveffa (Saint Genevieve)*. With her are actor Frank Mascella (left) and Commendatore Clemente Giglio, who produced and directed many spiritual plays like this one. Plays with religious themes were sometimes written by the priests.

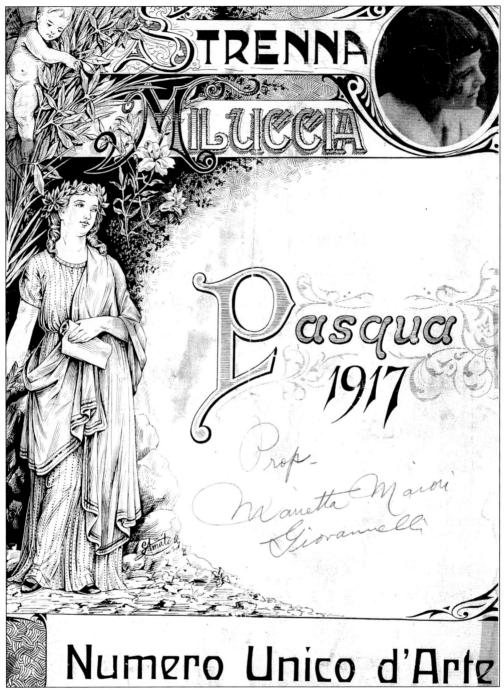

STRENNA MILUCCIA

Pasqua 1917

Prop.

Marietta Maioli
Giovannelli

Numero Unico d'Arte

Pasqua 1917, written and compiled by Toto Lanza, was a charming souvenir magazine for the Easter holiday of 1917. The editor, Salvatore "Toto" Lanza, featured the celebrities of the time in Little Italy in what was supposed to be the first of many other editions.

Diana Baldi had a career on Italian radio and, in 1945, narrated the colossal religious production *Passione e Morte di Nostre Signore Gesu Cristo* (*Passion and Death of Our Lord Jesus Christ*), starring Frank Polimeni as Jesus. It was billed as "the greatest and most complete realization of the tragedy of Golgotha." The play was adapted from the New Testament by Msgr. Antonio Martini. Diana also advertised cosmetics, specially priced for Easter.

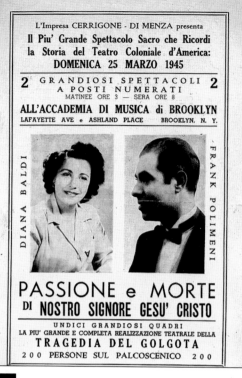

L'Impresa CERRIGONE - DI MENZA presenta
Il Piu' Grande Spettacolo Sacro che Ricordi la Storia del Teatro Coloniale d'America:
DOMENICA 25 MARZO 1945

2 GRANDIOSI SPETTACOLI **2**
A POSTI NUMERATI
MATINEE ORE 3 — SERA ORE 8

ALL'ACCADEMIA DI MUSICA di BROOKLYN
LAFAYETTE AVE e ASHLAND PLACE BROOKLYN, N. Y.

DIANA BALDI

FRANK POLIMENI

PASSIONE e MORTE
DI NOSTRO SIGNORE GESU' CRISTO
UNDICI GRANDIOSI QUADRI
LA PIU' GRANDE E COMPLETA REALIZZAZIONE TEATRALE DELLA
TRAGEDIA DEL GOLGOTA
2 0 0 PERSONE SUL PALCOSCENICO 2 0 0

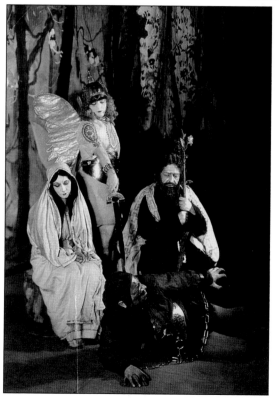

The traditional Neapolitan Christmas presentation is *La Cantata dei Pastori* (*The Shepherd's Song*). The story has many variations and adaptations of this general theme: Mary and Joseph travel to Bethlehem and, before the birth of Christ, encounter several characters, including demons and a protective angel. In this Clemente Giglio adaptation, the ubiquitous Stella Bruno (seated) starred as Mary, Nino Orlando as St. Joseph, and Lina Maresca as the angel.

Fr. Antonio Demo (left) (1870–1936) was active in the St. Raphael Society and the Italian Benevolent Society, both located north and west of Little Italy. He was also pastor of Our Lady of Pompei (below) (the Church of Holy Mary of the Rosary of Pompei), at 212 Bleecker Street, which had been founded in 1891 by Scalabrinian Fr. Pietro Bandini (1853–1917), who also founded the St. Raphael Society for the Protection of Italian Immigrants. Father Demo celebrated masses for the departed victims of the Triangle Shirtwaist Factory Fire in 1911, among them Sophie Salemi and Della Costello of Cherry Street. The original church building was used by a Unitarian Universalist congregation as early as 1836; the Franciscan friars later bought it, and it was known as the African-American Roman Catholic congregation of St. Benedict the Moor until 1883.

Scalabrinian missionary Rev. Gaspare Moretti (1880–1924) worked with missionary Frs. Pietro Bandini and Giacomo Gamera at the St. Raphael Society, particularly at Ellis Island when immigrants were just landing. Moretti was also the chaplain of St. Raphael's Home for Italian Immigrants. He was a photographer of the Italian immigrant experience; many of his photographs grace the pages of this book.

The religiosity of Little Italy's southern Italians was a complex mixture of their Roman Catholic faith and centuries-old traditions, beliefs, and superstitions. Almost everyone had a dream book, which, as the picture shows, unlocked the symbols in dreams. This dream book, compiled by Antonio De Martino, was published by his Italian Book Company, 145–147 Mulberry Street, as late as 1944 and guaranteed the interpretation of 10,000 dreams.

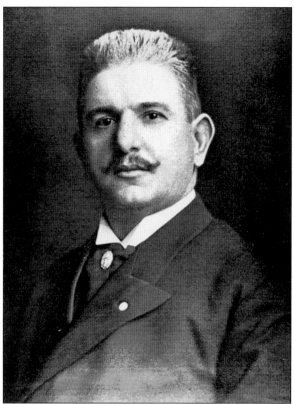

The last sacrament a Catholic receives is extreme unction, the blessing before death. Afterward, Little Italy's Italians were usually taken for their last ride by the undertaker Carlo Bacigalupo. Bacigalupo's name turned up in the 1940s in Louie Prima's songs and Lou Costello's jokes. The expression "Bye-Bye Bacigalupo" needs no explanation. Born in 1863, in Cichero, near Genoa, and migrating with his family to New York when he was seven years old, Bacigalupo became a mortician and founded his first funeral home in 1888, with branches, stables, and offices at 26^1/$_2$ Mulberry Street, 208–210 Spring Street, 95 Park Street, and 26 Mott Street. When necessary, he was helpful and generous to the immigrants. After his death his wife, Catherine Bacigalupo, ran the business. Bacigalupo's sister Caroline married John A. Perazzo, who in 1908 expanded the family funeral business to Greenwich Village.

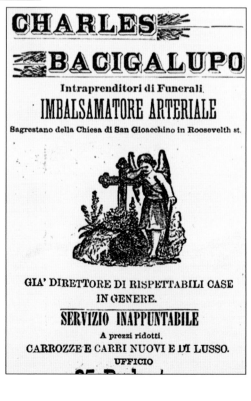

CHARLES
BACIGALUPO

Intraprenditori di Funerali.
IMBALSAMATORE ARTERIALE
Sagrestano della Chiesa di San Gioacchino in Rooseveth st.

GIA' DIRETTORE DI RISPETTABILI CASE
IN GENERE.
SERVIZIO INAPPUNTABILE
A prezzi ridotti.
CARROZZE E CARRI NUOVI E DI LUSSO.
UFFICIO

Four

BANKING

BANCA ITALIANA

109 Mulberry St., New York.

EUGENIO BOCCIERI, Prop.

Si spediscono danari in Italia ed in qualsiasi Citta' Americana ed Europea con la massima sollecitudine e scrupolosita,

Si fanno biglietti d'imbarco con la massima economia.

UFFICIO DI COLLOCAMENTO AL LAVORO

Mulberry Street was called the Italian Wall Street because it housed so many banks. Before stricter banking regulations went into effect, banks proliferated in Little Italy and served more eclectic purposes than a savings and loan company. A typical banking office could also double as travel agency, wine shop, import-export enterprise, postal and telegraph center, money exchange, employment agency, notary public, theatre ticket outlet, or cigar store; it assisted customers with sending money back to Italy, sometimes writing letters for the illiterate immigrants. An Italian bank was a kind of community center. Eugenio Boccieri was an honest banker, the proprietor of the Banca Italiana, at 109 Mulberry Street, in 1907, who offered employment and travel services and promised careful and scrupulous efficiency in sending money to American and European cities. Some bankers, however, were not honest. *Padroni* would engage newly arrived immigrants as laborers on track gangs and pay miserable wages for long hours of work. The boss made his profits from the railroad company. Some crooked bankers would close their doors one morning and escape with immigrants' life savings.

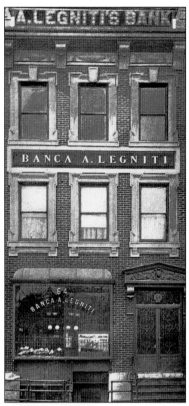

Don Angelo Legniti was born in Monteforte Irpino, Avellino, Campania, in 1858, and emigrated in 1886. His Banca A. Legniti was located in this three-story building (left) in 1903, at 64 Mulberry Street, where his six man staff poses (below). He also had branches at 69 Mulberry Street, opened in 1891, and at 89 Mulberry, opened in 1890, and a banking partnership with a Mr. Tropeano at 72 Baxter Street, beginning in 1906. In 1890, he served on the Board of the Italian Institute and organized benefits for community concerns at the Villa Penza, at 198 Grand Street. At his home he hosted an annual New Year's Eve celebration, which was often attended by Enrico Caruso, as well as the vaudeville stars of the Italian music halls, Eduardo Migliaccio and Guglielmo Ricciardi. Legniti lived on 12th Street at 2nd Avenue in 1900 and moved to 325 East 13th Street in 1902.

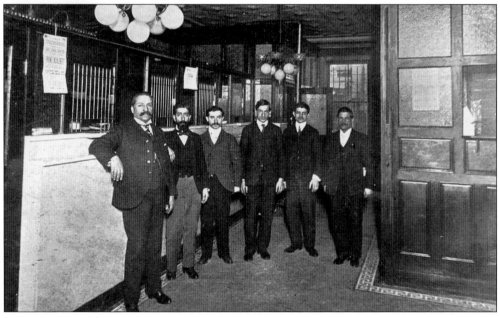

The sign for the Banca Stabile (right), established in 1882, overpowers Caffe Bella Napoli at 151 Mulberry Street. Banca Stabile means "stable bank" and was meant to inspire confidence. The sign offers telegraph, postal, travel, and notary services and savings accounts. The building next door, at 149 Mulberry Street, an example of Federalist merchant house architecture, with dormers still intact, was the home of Stephen Van Rensselaer in 1816. The first floor was a shop. In 1903, it became the Italian Free Library. The address later housed the Italian Book Company. The Banca Stabile (below) occupied 189 Grand Street, on the busy southwest corner of Mulberry Street. It still stands, a nostalgic symbol of the past. It has tin ceilings, terrazzo floors, and brass tellers' cages. Gilt lettering on a tellers' cage advertises steamship tickets.

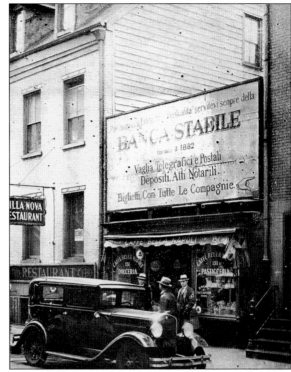

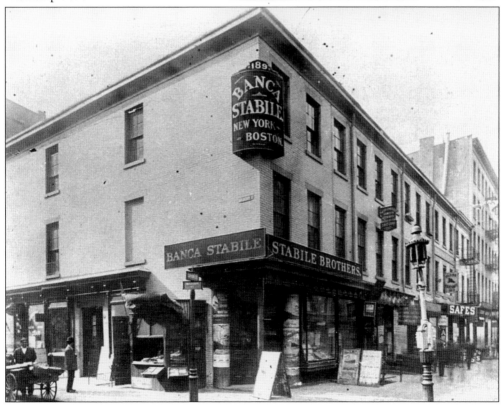

BANCO DI NAPOLI

FONDATO NEL 1539

Capitale e riserva Lit. 125.728.000,00
Biglietti propri in circolazione al 10 ottobre 1918
Lit. 1.899.855.350
Riserva per la circolazione Lit. 313.664.452

DIREZIONE GENERALE IN NAPOLI

60 Filiali in Italia - Filiale a Tripoli (Africa)
Filiali di recentissima apertura a
TRENTO - GORIZIA - TRIESTE

Corrispondenti nelle principali citta' del mondo

AGENZIE NEGLI STATI UNITI
PER RIMESSE IN ITALIA A MEZZO TRATTE-TELEGRAFO
VAGLIA SPECIALI GARANTITI
gli unici riconosciuti dal R. Governo ed ammessi a paga-
mento dagli Uffici Postali del Regno

Per altre operazioni di Banca e
SERVIZIO DEL DEBITO PUBBLICO ITALIANO

NEW YORK - 1) Broadway, Spring & Crosby sts.
2) 353 East 149th st.
CHICAGO - So. Halsted & Froquer sts.

The Banco di Napoli (Bank of Naples), founded in 1539, had an excellent reputation, with offices at 526 Broadway near Grand Street, and on Spring and Crosby Streets. More importantly, it partnered with many of the bankers in Little Italy. They acted as the bank's New York representatives. Since so many early Little Italy residents were Neapolitan, it did a thriving business.

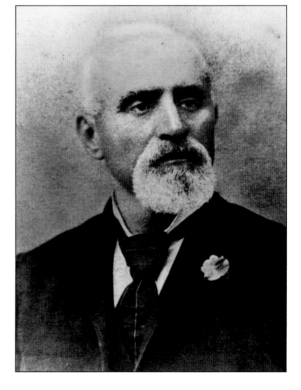

Antonio Cuneo, born in Soglio, Liguria, emigrated in 1855. He opened a grocery shop on Baxter Street and, with the store profits, bought tenements in Mulberry Bend in 1880 and real estate at 37 Mulberry, to which he relocated in 1881. He also opened the Banca A. Cuneo & Company. In 1888, he moved to a building that he erected at 28 Mulberry Street. He resided at 101 Park Street, and he died in 1896.

Antonio Cuneo left his bank to his nephew Andrea Cuneo (right). Born and educated in the United States, Andrea succeeded his Italian-born uncle as proprietor and carried on the business at 28 Mulberry Street, with an additional branch at 48 Harrison Street in 1903. The undertaker Carlo Bacigalupo's sign is displayed below; Bacigalupo rented space from Cuneo at 26¹/₂ Mulberry Street. Cuneo was included in a satirical song of the period, "*Il Contabile*" ("The Bookkeeper"), about a recently hired bank clerk lacking mathematical ability. In the song, the bank clerk, who cannot add, lists the major Italian-American bankers of the day. The verse ends with the complaint: "Accounts that don't balance make squash out of me. Nine and six fifteen plus seven twenty-three."

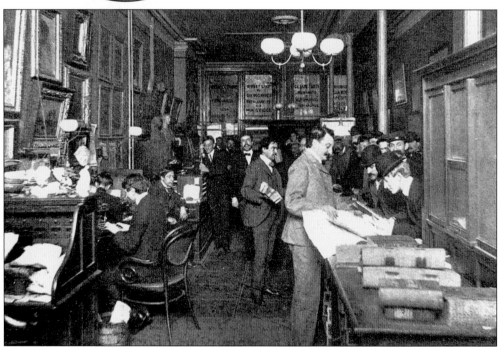

Cesare Conti was born in Pontremoli, Tuscany. He emigrated at age seven and, in 1884, established the Banca Cesare Conti, also a representative of the Banco di Napoli. His main office, at 35 Broadway, had the emblem of the House of Savoy, Italy's former royal family, on the door. A member of the Italian Chamber of Commerce of New York in 1906, Conti owned several Little Italy bank branches and smaller businesses.

Conti also owned a firm that imported Italian products, an Italo-American Store, bank annexes in Philadelphia and Newark, and this maritime service and steamship ticket agency c. 1906. Visible in the picture are customers lined up and busy workers at the typewriter, on the phone, and at the service counter (possibly Conti himself), while a messenger sits and waits. Conti also served on organizational committees that sponsored community benefits.

Fausto D. Malzone was born in Castellabate, Italy, immigrated to the United States in the 1870s, and lived on Elizabeth Street. His middle initial stands for his given name, Domenico, which he changed to Fausto because his favorite opera was Giuseppe Verdi's *Damnation of Faust*. His bank at 88¹/₂ Mulberry Street, located between Bayard and Canal Streets in the heart of Mulberry Bend, operated from 1886 to 1902 and was also the headquarters of his amateur theatre group, Il Circolo Filodrammatico Italo-Americano, which performed only benefits for Little Italy charitable causes. He advertised money changing, postal services, travel services by ship or rail, and imported Italian wines. As a banker, Malzone was a respected member of the Italian immigrant community. He also served as honorary vice-president of the Stella d'Italia Society, the Italian Barbers Society, and the Sant' Arsenio Military Society. In 1902, Fausto became ill with malaria, from which he died in 1909. The building at 88 Mulberry Street is now a Chinese butcher shop.

Pasquale Caponigri was born in Ricigliano, Province of Salerno, Campania, on March 16, 1855. His father, Gaetano Caponigri, was a captain in the 1848 Revolution in Italy and died there in 1860, unfortunately before he could see a united Italy, for which he had fought, unified by Garibaldi's legions. The Italian government denied Gaetano's widow a proper pension because of Caponigri's political involvement, and so Gaetano's son Pasquale immigrated to the United States in 1878. Pasquale Caponigri founded his first banking office, Banca P. Caponigri, at $55^1/2$ Mulberry Street, in 1880. He later moved his banking business to 20 Mulberry Street. His son, Giuseppe Ferruccio Caponigri, was a graduate of Manhattan College and Columbia University Law School.

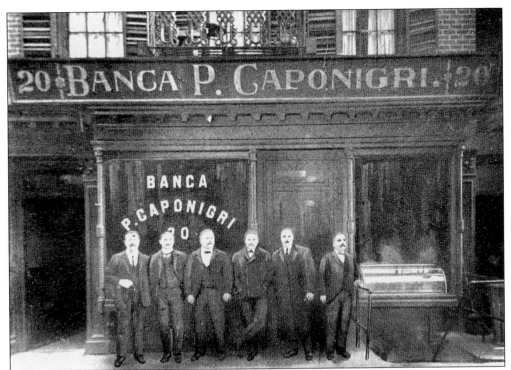

Pasquale Caponigri (third from the left) moved his banking business, the Banca P. Caponigri, from 55¹/₂ Mulberry Street to 20 Mulberry Street in 1890. With him in front of the bank are members of his staff. The new location also served as substation No. 23 of the New York Post Office.

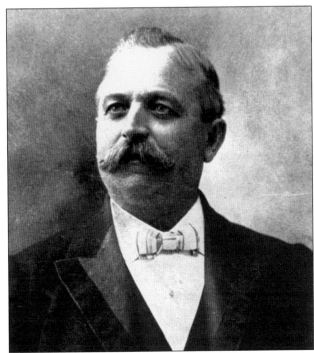

The banker Antonio Sessa resided and had banking offices in Brooklyn, but he was very much involved with philanthropic organizations in Little Italy and produced community benefits. Sessa was born in 1849 on the Sorrento peninsula and came to New York with his family in 1877. In 1895, he funded the first theatre built for the Italian-American stage, Union Hall. He was also president of La Societa' Torquato Tasso mutual benefit association in 1902.

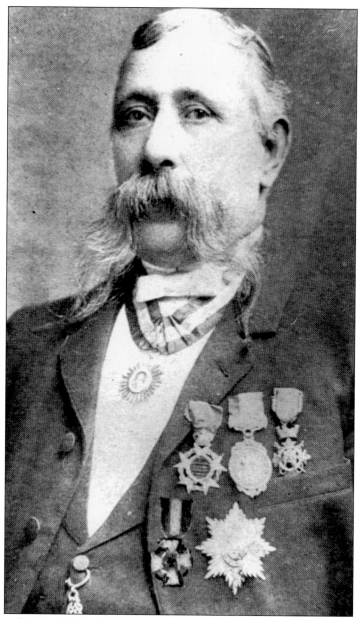

Louis V. Fugazy (1839–1930), originally Luigi V. Fugazzi, grandfather of Bill Fugazy, founded his Banca L.V. Fugazy, including public notary and travel agency, in 1870 at 145 Bleecker Street (also the location of the J.G. Marsicano wholesale cheese company). Fugazy relocated next door to 147 Bleecker at Broadway in 1895, by which time he had been knighted *Cavaliere* by the Italian government. Above, Fugazy wears the *Cavaliere* medal, among other honorary awards. In 1904, he became *sub-corrispondente* to the Banco di Napoli and relocated to 153 Bleecker (the basement of which once housed the notorious Black and Tan saloon in 1881). In 1905, Fugazy had another branch office in the old Hotel Colombo, at 149 Bleecker Street. By 1921, he was serving on the board of directors of the Italian Savings Bank, founded in 1896 and located at 62–68 Spring Street, at Lafayette. Fugazy was president of the Societa' Italiana di Beneficenza, at 136 West Houston Street.

Five

FOOD

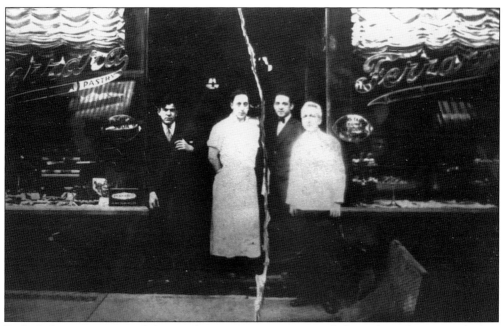

Early Italian immigrants did not adapt to American eating habits when they arrived; they brought with them their regional cuisine as a way of retaining identity. However great the need for bankers may have been, there was much more need for food importers and grocery stores, *salumerias* and *latterias*, and restaurants and *caffes*. Among the wholesalers were E.F. Angelicola, M. De Rosa, Antolini, the Sapone Marco Cuneo family, the Rinaldi brothers of Lafayette Street, Ernesto Russo and Giovanni Lazzatto of Water Street, and Egisto Mariani of Centre Street, who represented 27 Italian food firms. Francesco Bertolli supplied oil and cheese, S. Rizzo had wholesale bananas, and Antonio Ferrara served the *dolci* (the sweets). Among those pictured are Caffe Ferrara manager Eduardo Scoppa (second from the right) and Ettore "Willie" Scoppa (in the apron).

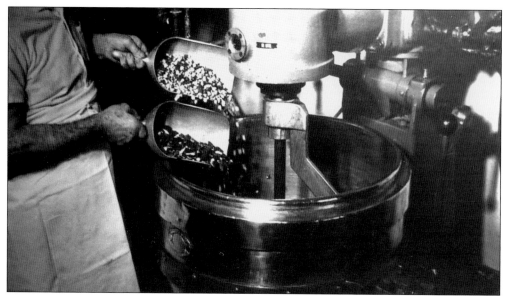

Caffe Ferrara became known for its *torrone*, the traditional Italian nougat candy. A baker (above) pours large amounts of whole almonds and filberts while a huge mixing machine blends the nougat candy ingredients. Whole nuts are used rather than chopped nuts because the entirety of the nut is what retains the flavor. This method of making Italian nougat candy is a time-honored style that is practiced in and brought over from the region of Benevento. Since there is no dairy in the candy, it packages and ships easily. For this reason, during World War II, many Italian-American soldiers overseas received *torrone* from their families at home via Ferrara's. At the store (below) *torrone* is packaged and ready for consumption.

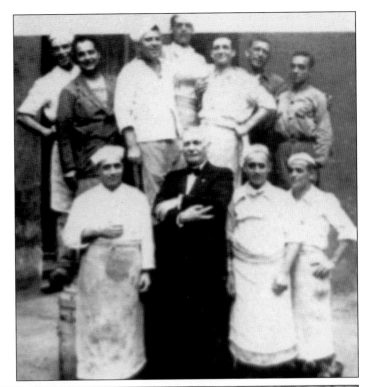

Antonio Ferrara poses with his coterie of *pasticcieri* (pastry makers). In 1892, he opened his *caffe* at 195 Grand Street so that after theatre or the opera, he and his friends, the *artisti*, could relax over coffee and play the card game *scopa*. Many bakers who started at Ferrara's went on to start their own bakeries in later years. Former partner Enrico Scoppa and Nicola Alba each opened their pastry shops in Brooklyn.

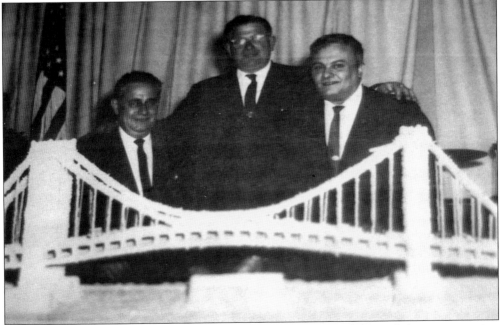

The inventive and creative Anthony Lepore of Ferrara's supervised the week-long construction of this unique Verrazzano Bridge sculpture in sugar, celebrating the new bridge in 1965. The glucose bridge was on display at Staten Island's Tavern-on-the-Green, owned by Dominic "Dee" Coppotelli (left). Also admiring the bridge were Anthony Pietracatelli (center) and James Scali.

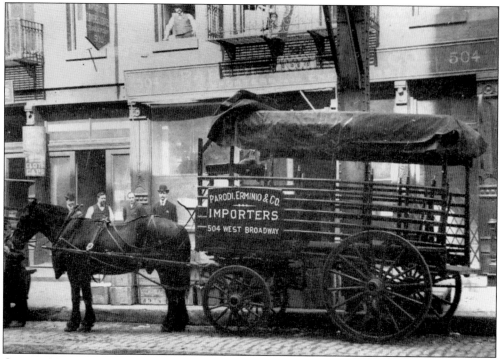

Quirino Vincenzo Parodi and Marcello Erminio were partners in an import-export business at 504 West Broadway. Erminio's father, Alessandro, owned an import business in Genoa and sent his son to New York in connection with it. The younger Erminio met Parodi and entered into the import-export business with him. Parodi had migrated from Genoa to New Dayton, Ohio, where he first opened a business. In 1897, Parodi relocated to New York. The company's horse-drawn delivery wagon (above) is parked in front of the importing firm's headquarters, c. 1906. The street has trolley rails and is still paved with cobblestones. The export department was at 550 West Broadway. The company had among its products Lucca "sublime" olive oil (below), for which it was the sole agent in the United States and Canada. Parodi and Erminio ran a number of businesses, including a sawmill in Caddogap, Arkansas. Parodi married the daughter of Giovanni Lazzatto, head of another New York Italian import-export company.

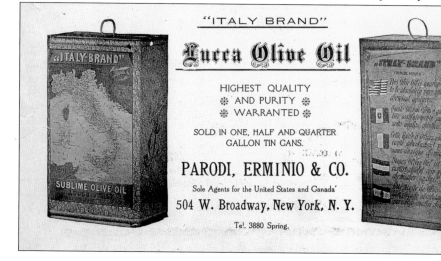

Grande ed antica Pizzeria Napoletana

53 SPRING ST., NEVW YORK.

Giuseppe Amabile **PROPRIETARII** Agostino Perera

Economia ed igiene
si riscontra in questo locale, oltre la
freschezza e la squisitezza del genere

Cucina perfettamente napolitana. **Servizio inappuntabile.**

E' aperta questa pizzeria fino a tardissima ora della notte.

Giuseppe Amabile and Agostino Perera were the owners of the Pizzeria Napoletana, at 53 Spring Street, in 1907. They promised economy and hygiene, fresh ingredients, perfectly Neapolitan cuisine, faultless service, and late hours. Their pizzeria was right across the street from Francesco De Caro's Flag Company, at 50 Spring Street, and Giovanni Vecchio's Singer Machine Store, at 54 Spring Street.

Gennaro Lombardi emigrated from Naples in 1895. He began making pizza in a bakery on Mulberry Street, using the same dough recipe his father and grandfather had used in Naples. He opened his own store on Spring Street in 1897. Lombardi's received its business license in 1905. Many pizza makers learned the trade from Lombardi. Gennaro Lombardi, grandson of the original, continues the store today at 32 Spring Street with partner John Brescio.

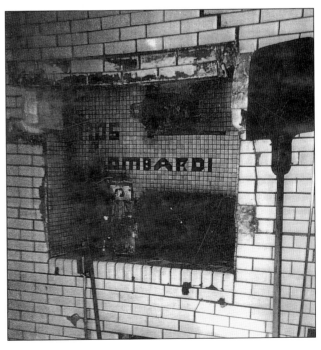

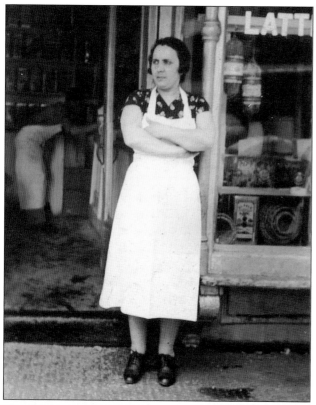

Sevino Di Palo emigrated from Basilicata in 1903 and opened his *latteria*, a dairy store, where he made fresh cheese, on Mott Street in 1910. In 1914, his daughter Concetta (left) arrived in the United States. In 1922, she married Luigi Santomauro (below, right, with son Sevino, center), who had emigrated from Montemelone in 1911. The couple lived at 115 Eldridge Street in a building and neighborhood mixed with Eastern European Jewish immigrants. They opened a dairy in 1925 at 206 Grand Street (still operated by the family today), but Luigi's sister already had a dairy on Mulberry Street named Santomauro, so Luigi named their store C. (for Concetta) Di Palo.

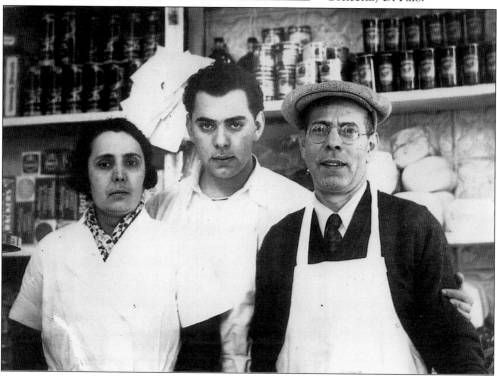

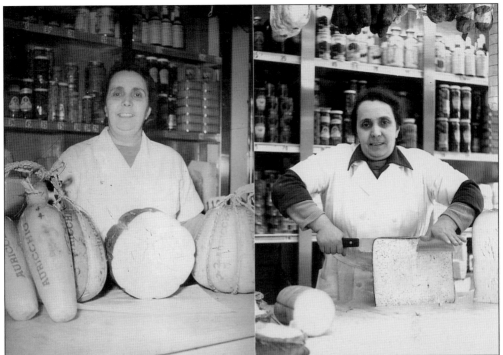

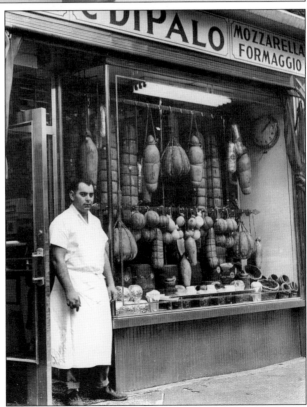

Concetta Santomauro cuts and dispenses cheese in her *latteria*. Following the death of her husband, Luigi Santomauro, after World War II, Concetta maintained the store, working with Luigi's brother Michael and her two sons, Michael and Sevino "Sam" (right). That year, the store was renovated with a more modern look, which remains. After Concetta died in 1956, the two brothers continued to run the business until their deaths. Today, Sam's three children, Luigi, Salvatore, and Marie, steadfastly keep the Italian *latteria* tradition in operation.

At 477–481 Broome Street, just west of Broadway, was P. Margarella, in 1921 the sole manufacturer of the "World's Fair Brand" of chocolates and bonbons. Journalist Mario De Biasi visited the company's laboratories, described them as neat and clean, and watched dark chocolate filaments drying, passing from one machine to another and ending up in shapes such as stars, globes, cubes, and rectangles. The factory had machines to toast the chocolate, refrigerators, ice machines, storage for sugar, and thousands of bags of cocoa beans, of which 400 bags a month were used. The cocoa was first toasted, crushed into powder, and then transformed into dough together with sugar. An Italian immigrant (above) works in the cream unit; another (below) supervises the chocolate cauldrons.

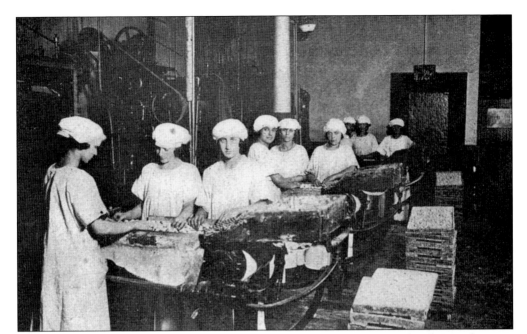

Young Italian women, dressed in white, work at the dipping machines, dipping candies into chocolate at Margarella's candy factory. Most of the employees were Italian immigrants. At noon, a bell sounded for lunch recess, which was provided in a restaurant in the factory. There were washrooms, dressing rooms, and an infirmary for the women, in case of illness. Women also packed the chocolates into their boxes.

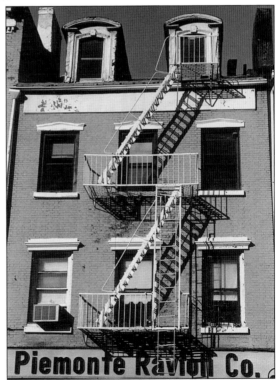

A man from Genoa had started Piemonte Ravioli Company in 1920 at 190 Grand Street, but in 1955, Mario Bertorelli from Parma took over the store. Mario and son Flavio run the business today. Giuseppe Maiori, the photographer of many Little Italy celebrities, lived in and worked out of this building. It was also the location for the Italian Barbers Supply & Perfumery Company in 1903 and for Maestro V. Ussano's music school in 1921.

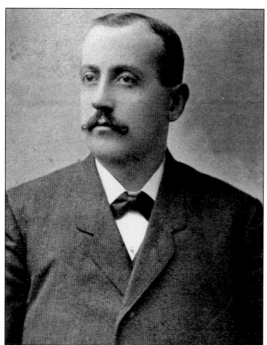

In the days before Prohibition, many Italians imported and distributed wholesale liquors and wines. S. Ciancimino, at 200 Bleecker Street, Ravenna natives Gaetano and Luigi Marchesini, and the Acone brothers, at 161 Mott Street, were among them. Serafino Piana (left) a native of Milan, was also a manufacturer and importer of wines and liquors *c.* 1906. He had a store at 93 Baxter Street. A descendant, Victor E. Piana, was still running the business at this address in 1921.

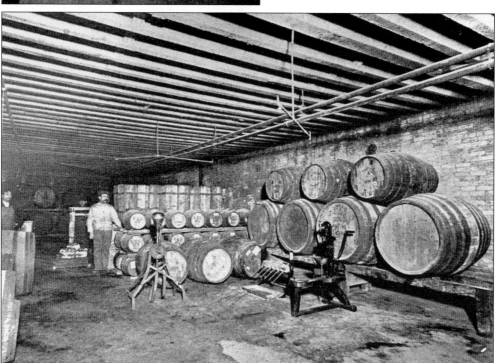

Luigi Gandolfi, a native of Codogno, imported and distributed food and wine from the Lombardy region of Italy. His business was located at 427–431 West Broadway. The picture shows barrels of wine in his storeroom *c.* 1906. Machinery for bottling wine is visible on the floor in the front of the barrels. Gandolfi also had a workroom for bottling sparkling wine and machinery for corking wine bottles. He stocked $24^1/2$-gallon Sopraffino wine.

Francesco Pennacchio emigrated from Guardia dei Lombardi, a little town in Campania, c. 1880 and settled in New York. He owned a *salone* (bar) at 109 Mulberry Street, which he sold in 1903, a beer garden called Francesco Pennacchio Grande Birreria, at 75 Mulberry, in 1903, at least one tenement, and one of the first movie houses or nickelodeons in New York City c. 1915.

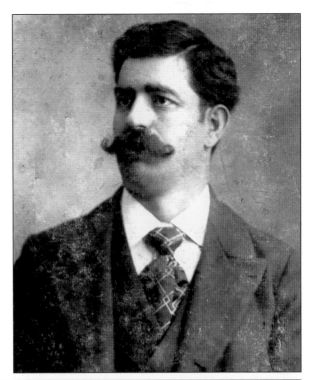

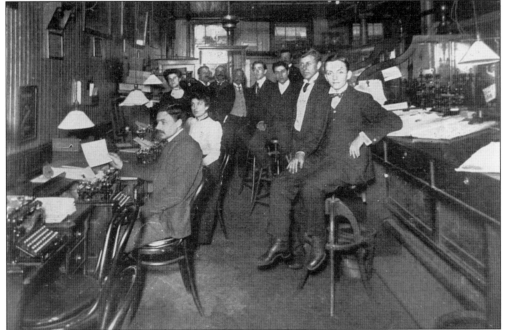

Achille Starace was born on November 5, 1851, in Vico Equense, Campania. He came to New York in 1870 and apprenticed himself to Funch, Edye, & Company, steamship agents. From 1876 to 1881, he was at the firm's Baltimore office, but he returned to New York to organize Starace Brothers, food importers and exporters. His office (above) was located at 76 Pearl Street c. 1906.

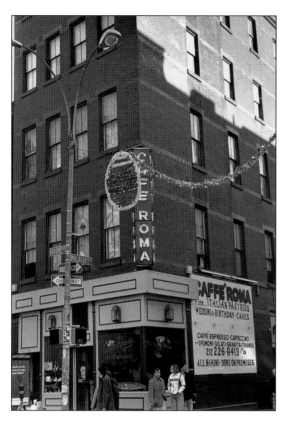

The current Caffe Roma, at 385 Broome Street, on the corner of Mulberry, was originally the pastry shop Caffe Ronca. The *caffe* was the Sardi's of Little Italy, a hangout for writers, journalists, socialist activists, singers, and variety artists. Pasquale T. Ronca was born on June 7, 1866, in Solofra, Avellino. He came to New York in 1891, followed by his brother Giovanni in 1892, with whom he opened Caffe Ronca.

ALLO SCOGLIO DI FRISIO

Grande rivendita di frutti di mare di qualsiasi specie tenuta dal cosidetto

"Ciccio 'o Spagnuolo"

in 109 Mulberry St. **New York**

Ch'e' stato il primo, se non l'unico, che ha riportati gli usi proprio napoletani, per lo smercio dei frutti di mare.

Si ricevono ordini e commissioni di dualunque impartanza.

"Ciccio 'o Spagnuolo" (Ciccio the Spaniard), the seafood vendor, had a fresh fish stand near the entrance to 109 Mulberry Street, where he sold many varieties of fish cooked in the authentic Neapolitan manner. The stand's sign, *Allo Scoglio di Frisio* (from the rocks of frisio), attests to the freshness of his merchandise.

No matter how famous and excellent a restaurant's cuisine may be, such as the authentic Neapolitan cuisine offered by the 100-year-old famous Angelo's, of 146 Mulberry Street, no restaurant, fish stand, *caffe*, or pizzeria can compare to home-cooked food, eaten around an Italian family table. Friends and relatives of the La Barberas of Elizabeth Street enjoy wine with nuts and grapes after dinner (below). From left to right are the following: (seated) Antoinette Vitale, Patrina "Beattie" Macaluso, and Rose and Salvatore "Toto" Macaluso; (standing) Salvatore "Toto" D'Aleo, Celestina, Santo Grasso, Mary La Barbera Grasso, and Angelo Vitale.

966-1277 / 226-8527

Angelo's
OF MULBERRY ST., INC.

Finest
Neapolitan
Cuisine

Closed Mondays

146 Mulberry Street
New York, N.Y. 10013

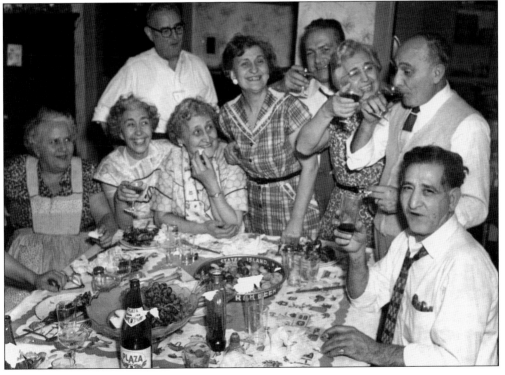

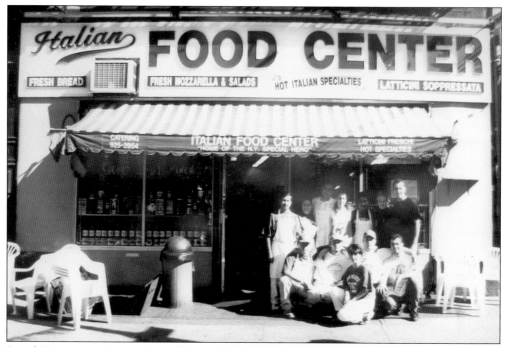

Joseph Demattia, the grandson of Fausto Malzone, opened the Italian Food Center at Mulberry and Grand Streets in the mid-20th century and then moved to a larger location at 186 Grand Street, across the way. He provided imported Italian foods, mozzarella, and sausage. After his death, the family sold the business to two former employees, Joseph Ferrara and Salvatore Bonnello, who run it today.

Francesco Alleva started his cheese store (the first and oldest in the United States) in 1892 at 190 Grand Street; he moved next door to 188 Grand Street after the Gran Caffe d'Italia dei Fratelli Gargiulo, of brothers Giuseppe and Fedele Gargiulo, closed c. 1904. Francesco had eight sons, all in the business. His oldest son, Henry, with his sister Irma, ran the store after Francesco's death. Then, Henry's son Robert ran the business, which is now owned by Robert Jr.

Six

ENTERTAINMENT

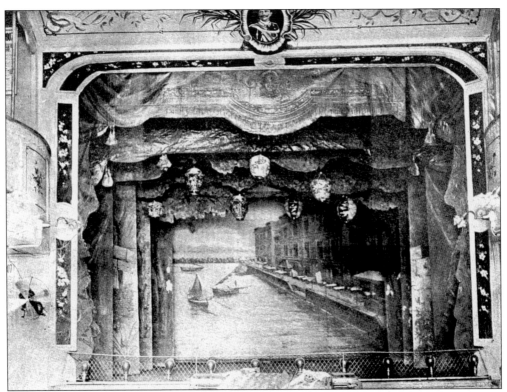

The Villa Vittorio Emanuele III, named after the reigning king of Italy, celebrated its grand opening and inauguration on November 24, 1904. It was a very popular early *caffe concerto* (Italian vaudeville music hall) of the type that proliferated all over Little Italy and in which variety entertainments took place. A portrait of the king, by the artist Gaetano Sorrentino, adorns the top of the proscenium arch. The Villa Vittorio Emanuele III was located at 109 Mulberry Street, between Canal and Hester Streets.

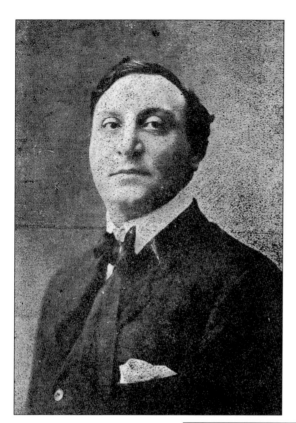

Guglielmo Ricciardi was born on July 12, 1871, on Via Savino No. 15 in Sorrento, Naples. He left his hometown in 1889 and came to New York, where he formed the Italian Comedy-Drama Company and performed and sang in all the Little Italy theatres. Ricciardi, with his intense features and big, oversized nose, was referred to as the Cyrano de Bergerac of the Italian theatre and as "Nasone" (big nose).

Concetta Arcamone and her sister Rosina were amateur actresses in their native town of Torre Annunziata. Concetta was 19 when she arrived in America. Guglielmo Ricciardi taught Concetta how to sing and dance and eventually married her. She later left her husband after falling in love with actor Antonio Maiori and becoming the leading lady of his troupe. Concetta and Maiori lived above their Teatro Italiano, at 24 Spring Street.

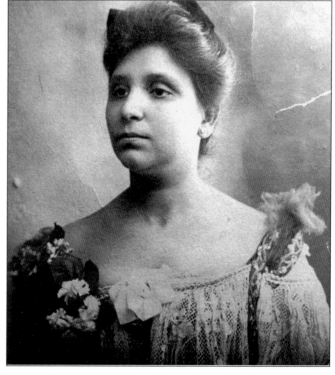

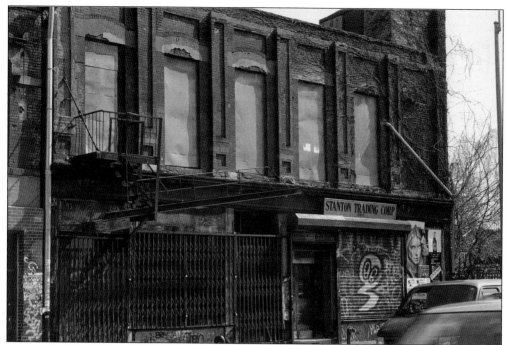

The Germania Assembly Rooms, at 291–293 Bowery, between Houston and Bleecker Streets, had a lobby and a spacious, upstairs room with 448 seats. Called the Teatro Italiano when il Circolo Filodrammatico Italo-Americano produced the drama *L'Entrata di Garibaldi in Napoli* (*Garibaldi's Entrance into Naples*) on February 21, 1883, the hall was shared with other Italian-American amateur companies, rifle clubs, marching societies, musical leagues, social and political organizations, and German and French societies.

Antonio Maiori introduced Shakespeare to his immigrant audiences in Italian dialect productions, the first to do so. Here, he is costumed as Hamlet. During the early years after 1900, Maiori was the most prolific producer-director in the Italian-American theatre. He collaborated with other producers and directors and enjoyed the distinction of briefly bringing American audiences to his theatre on the Bowery. He produced French and Italian classics until he capitulated to producing variety theatre.

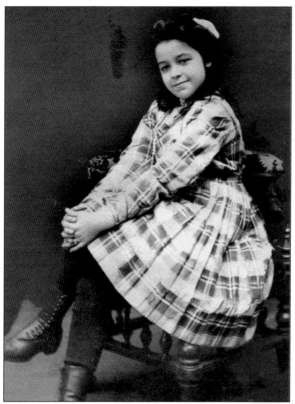

Marietta Maiori was the daughter of Antonio Maiori and Concetta Arcamone. Of all the Maiori children, she carried the theatrical gauntlet highest. Marietta regarded her father as her idol; he taught her everything about the stage. She was also known as Maria Giovanelli after she married Attilio Giovanelli, the distinguished violinist and concert master in 1916 at the Church of the Most Precious Blood, on Baxter Street. She had a wonderful career in the theatre. Marietta Maiori started out as a child actress (above) and made her debut on the Italian-American stage at 3:00 p.m. on Sunday, March 5, 1905, at the 1,800-seat London Theatre, at 235–237 Bowery, at Prince Street, where she appeared in the premiere of Nicola Misasi's dramatic work *Mastro Giorgio* (*Master George*). Marietta performed Ophelia (right) in Maiori's productions of *Hamlet* and also worked on Italian radio. She died in 1999, just two months short of her 100th birthday.

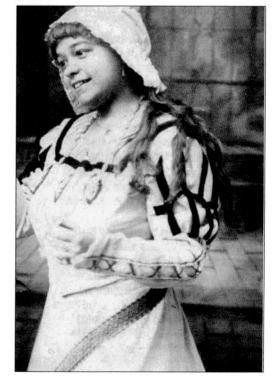

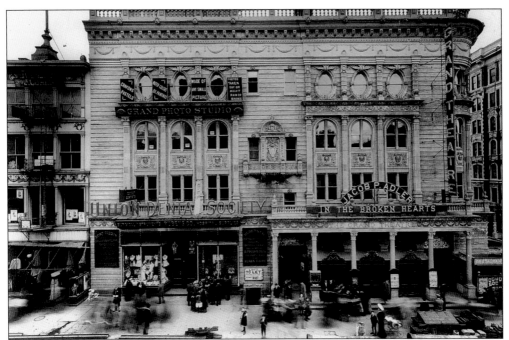

The Grand Theatre was located at 255 Grand Street, at Chrystie Street. Antonio Maiori produced theatrical productions there. Antonio Ferrara and Tony Bacarozzi also collaborated on the production of Italian opera at the Grand Theatre. In 1903, Maestro Salvatore Avitabile, who ran a school where he taught music and theatrical art, was co-director with Salvatore Nunziato of the Italian-American Lyric Company in the production of opera at the Grand Theatre, where he directed the orchestra.

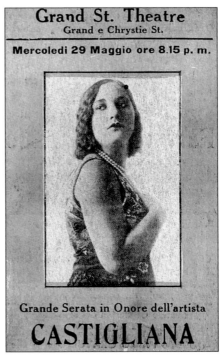

Grand St. Theatre
Grand e Chrystie St.

Mercoledi 29 Maggio ore 8.15 p. m.

Grande Serata in Onore dell'artista

CASTIGLIANA

Other Italian-American stars appeared at the Grand Theatre, such as Eduardo Migliaccio in 1929. He shared the bill with many stars for a benefit for La Castigliana. He performed O Cunduttore (The Conductor), with lyrics by Migliaccio and music by Maestro V. Napolitano. It is an impersonation of the old maestro who taught music and whose students composed the orchestras, played for intermissions of plays, and marched in the feast day parades.

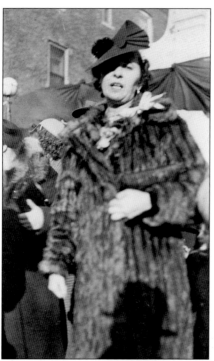

Mrs. Concetta Donigi frequently sang duets with her husband, Arturo Zacconi, the son of the actor Giuseppe Zacconi. The couple Zacconi-Donigi sang comic duets at theatres everywhere, and in Little Italy at La Villa Vittorio Emanuele III, 109 Mulberry Street; La Villa Mascolo Concert Hall, 207 Canal Street; Teatro Italiano-Drammatico Nazionale, 138 Bowery; a hall at 100 Mulberry Street; Teatro Italiano, 24 Spring Street; and the Germania Assembly Rooms, 291-293 Bowery.

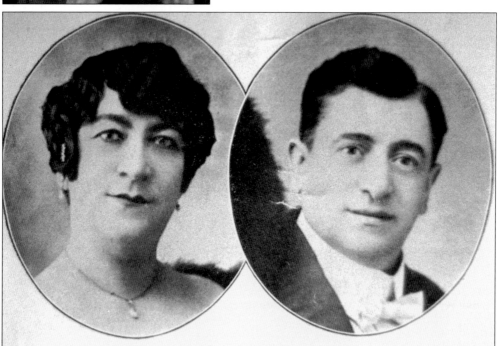

La Coppia Marconi (The Marconi Couple), was a comedic act for sure and was featured on the music hall circuit. Close examination of the cameo head shots shows that the couple are not together in the picture; the shots were taken separately and superimposed to look like they are together. This was also the essence of the quick-change act; closer examination reveals that the woman is really the man in drag.

This picture captures a moment in a variety show and the interior of an unnamed Italian music hall on the Bowery in 1890 (right). The early migration of the 1880s and 1890s brought many single, unattached men, as the picture shows. They gravitated to the Italian music halls and nightclubs, where they could hear the music and dialects of their hometowns in Italy. The Bowery was always a favorite location for entertainment. The first Bowery tavern was Cronelis Aertszen's Inn, opened in 1665. In the 19th century, the Bowery housed German beer gardens and Irish saloons. This unidentified theatre might have been the Windsor Palace, at 103 Bowery, the Teatro Italiano, the Columbia Opera House, at 104–106 Bowery, or the Teatro Italiano, at 138 Bowery. Anna and Roberto Chiaramella (below) performed a comedy act in the music halls, vaudeville theatres, and on the radio on station WFOV.

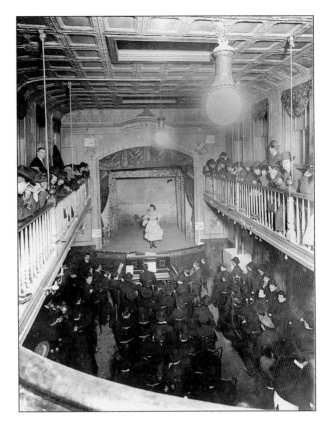

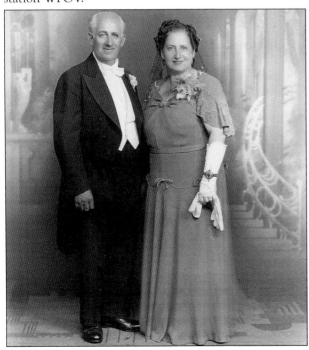

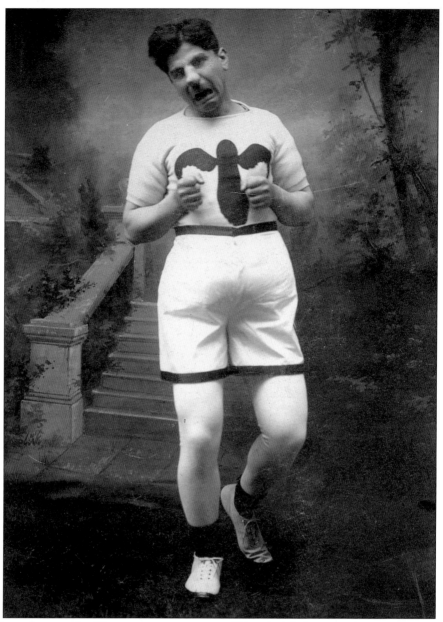

The legendary vaudevillian comic impersonator Eduardo Migliaccio, whose stage name was Farfariello, lived at 57 Kenmare Street. Migliaccio was born on April 15, 1882, at Cava Dei Terreni, Salerno. In 1897, he emigrated from Italy. In New York City, he got a job at the Banca Avallone, at 74 Mulberry Street, writing letters to relatives in Italy for the bank's immigrant clients who were illiterate laborers. This job gave him an understanding of the psyche of the Italian immigrant, which lies at the core of the characterizations he created on the stage. The job introduced him to the characters in the Italian community, the very subjects of the *macchietta coloniale* (colonial character sketch) that he invented and made famous. He was one of the most popular entertainers of the music halls of Little Italy, where he performed his *macchiette* (character impersonations). In 1936, he toured Italy, and King Victor Emanuel III named him a *Cavaliere dell'ordine della Corona d'Italia* in 1940.

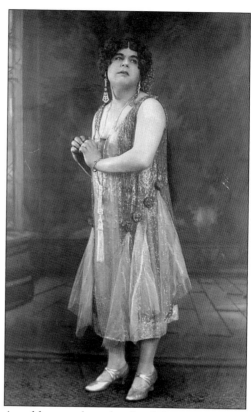

Farfariello's son Arnold remembers that his father's female impersonations were quite successful, partly because his father was not hirsute. The dresses pictured are only two of Farfariello's many female costumes, for which he had built special glass cases to protect them and make them easily visible. Above, Farfariello satirizes the modern woman in *La Donna Moderna*. On the left, he is *La Suffragetta* (*The Suffragette*). Other female sketches included *La Sposa* (*The Anxious Bride*), an ungainly, oversized bride; *Scul-gherl* (*The East Side School Girl*), who has a large repertoire of jazz songs that she sings from beginning to end, a parody of the opera diva Luisa Tetrazzini, with her trills and sentimental songs; and *Maritem'e' nglese* (*My American Husband*), which shows the point of view of an Italian woman undergoing assimilation—her advice to other Italian-American girls is "better to stay alone than to have a husband like this."

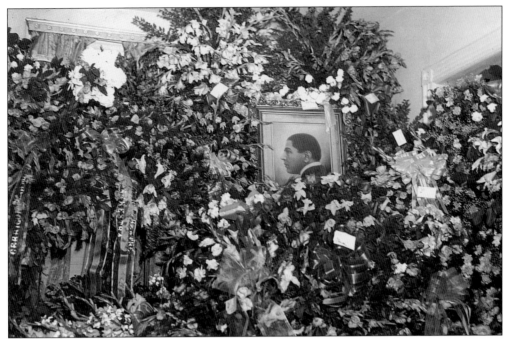

Eduardo Migliaccio died on March 27, 1946, and with him Farfariello, never to be seen again on the stage. His inimitable characterizations could not exist outside their creator. What is left is the memory of the smiling man behind the big noses, funny costumes, and crazy wigs who found an endearing way to make his compatriots, strangers in a strange land, feel at home.

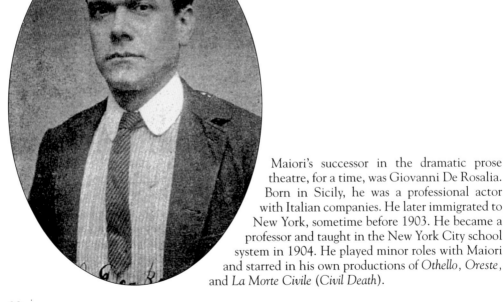

Maiori's successor in the dramatic prose theatre, for a time, was Giovanni De Rosalia. Born in Sicily, he was a professional actor with Italian companies. He later immigrated to New York, sometime before 1903. He became a professor and taught in the New York City school system in 1904. He played minor roles with Maiori and starred in his own productions of *Othello*, *Oreste*, and *La Morte Civile* (*Civil Death*).

Silvio Minciotti was born Francesco at Citta di Castello, Perugia, in 1882, and immigrated to New York in 1896. He started with the Maiori-Rapone Company at the Spring Street Teatro Italiano in 1900 as Carlo in *La Jena del Cimitero* (*The Hyena of the Cemetery*) and as Odoardo, son of Elizabeth the Queen, in *Riccardo Cuor Di Leone* (*Richard the Lionhearted*). In 1909, he joined Maiori's U.S. tour, arranged by Edwin Balkin. For Armando Romano's dramatic stage version in four acts of *Madama Butterfly*, Minciotti appeared in the role of Pinkerton. His first independent production was his friend Cordiferro's play *L'Onore Perduto* (*Lost Honor*) in 1904. In 1905, Minciotti was the director at the Villa Vittorio Emanuele III nightclub. He performed with the Italian actor Ermete Novelli on his tour to France, Germany, Russia, Hungary, and Romania, and acted with the Italian Virgilio Talli Company in 1906. Returning home, he married actress Ester Cunico in 1911, and together they formed their own professional company.

Italian food companies determined that Italian-language radio programs were excellent advertising vehicles. Italian-American actors were employed regularly, and theatre audiences increased. Hearing the plays on the radio in serial, soap opera form, listeners were teased into seeing the shows onstage. The story broadcast during the week would be performed live in the theatre on the weekend. Director Mario Badolati used another trick: he would close the radio week with a cliffhanger and provide the ending in the theatre. The Giglio Radio Theatre company (left) performs on WHOM c. 1937. The play is *U Cafe dei Critici* (*The Critics' Cafe*), starring Luigi Iaccarino as Gennarino the waiter, Bartolomeo Liscio (in the derby), and Renato Vinciguerra (center). Siblings Adelina and Sandrino Giglio, with the stage name Perzechella (below, overwhelmed by their radio fan mail), performed together in the Giglio Radio Theatre company, in vaudeville, and on radio.

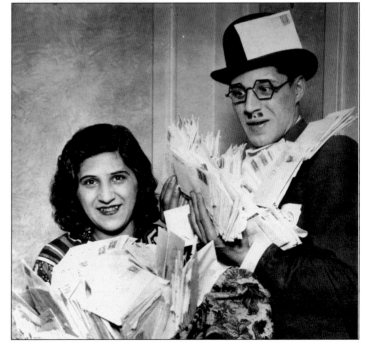

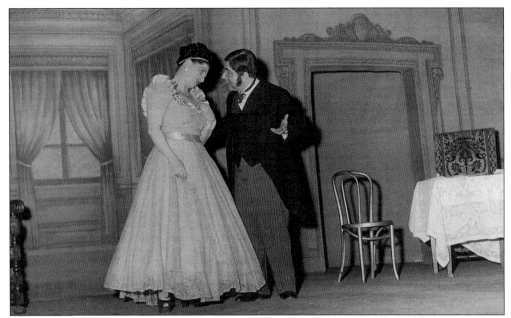

Another Clemente Giglio production was *La Zia di Carlo*, the Italianized adaptation of *Charley's Aunt*, a vehicle exploited for its comic scenes in drag. Sandrino Giglio, Clemente's son, plays the aunt, and Attilio Barbato costars. Clemente and his parents, the magician Don Alessandro Giglio and Adele Gravieri, immigrated in 1891 and lived at 246 Elizabeth Street. In 1897, Clemente Giglio formed his own theatre company.

This spectacular Giglio Production was *La Figlia del Dragone Rosso* (*The Daughter of the Red Dragon*), an Italian melodrama in Chinese costumes. From left to right are Nino Orlando, Lina Maresca, and Joe Ventrella. When Giglio wrote and performed his melodramas at the Thalia Theatre, at 46–48 Bowery, he would arrange to be killed in the first act so he could take over for his son Sandrino at the piano.

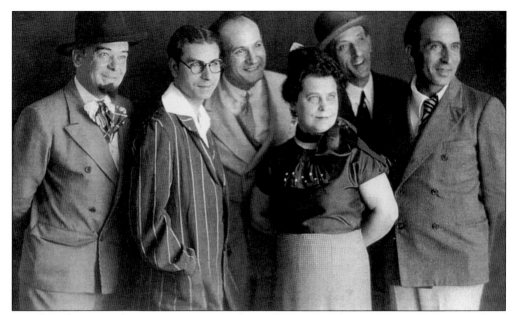

Angelo Gloria was born in Catania, Sicily, and immigrated to the United States, where he formed the Angelo Gloria Theatre Company. He hired Emma Alba Barbato to star and then married her and renamed his troupe the Donna Vicenza Company after their popular radio program. Gloria wrote and directed. The identifiable actors of this radio broadcast company are in front, from left to right, Aristide Sigismondi, Attilio Barbato, Emma Alba Gloria, and Angelo Gloria.

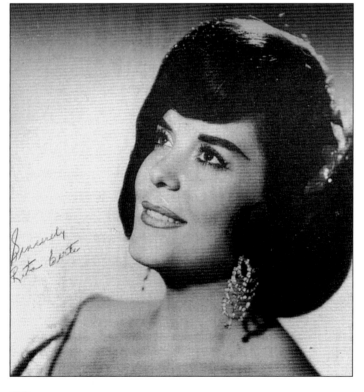

After seeing one of her shows in Italy, Gennaro Cardenia brought Rita Berti to America in 1953 to perform in his vaudeville productions, both plays and musicals. She was billed as "*la giovine ed elegante Stella*" (the young and elegant star). She was featured in Gennaro and Vincent Cardenia's *Il Festival del Teatro Mediterraneo di Napoli* (the Festival of Mediterranean Theatre from Naples) and also sang on the radio.

Oscar-winning actor Vincent Gardenia began acting at age five with the company of his father, the popular impresario, actor, and singer Gennaro Scognamillo Cardenia. Vincent performed regularly on Italian-American vaudeville stages everywhere until he made his successful entry into American theatre and films. He was fond of saying that everything he knew about theatre he learned working with his father.

Alberto Campobasso (standing, third from left) (1888–1961) was an imposing presence in the immigrant theatre, both because of his physical size and his output of work as writer, director, and actor. He is pictured with the cast, costumed for Giovanni Verga's drama *Cavalleria Rusticana* (*Rustic Chivalry*). Others in the cast included Frank Mascetta, Gaudio, Rapanaro, Cariti, and Rina Negri.

When Campobasso died in 1961, the Italian Actors Union displayed this tribute to him in its annual dinner dance booklet, an unusually large display that showed the esteem held for him by the Italian community. The graphic illustrates him at work, writing and directing. He is surrounded by characters from the Commedia dell Arte, Arlecchino, and Captain Brighella. Campobasso had a wife, Ester, and a son, Lucio.

Today's Italian Actors Union (affiliated with the Associated Actors and Artistes, AFL-CIO) was started in 1933. The original name was Lega di Miglioramento fra gli Artisti Italiani della Scena (League for Progress for Italian Theatre Artists). Its jurisdiction includes Italian language dramatic and musical productions. The Lega also published a journal, *Il Palcoscenico* (the *Stage*). In later years the association had meetings at the Villa Penza, at 198 Grand Street.

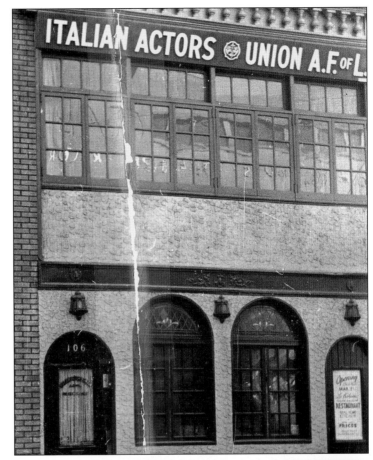

Mimi Cecchini Romeo (left) was president of the Italian Actors Union for many years before she died in 1992. She and Sal Carollo (right), executive secretary, meet with Harrison Goldin, New York City comptroller. Mimi was born in San Francisco in 1923 and started acting at age three. She progressed to her family's theatre, appeared in commercials, soap operas, and movies, and had her own Italian radio program. She also dubbed English films into Italian.

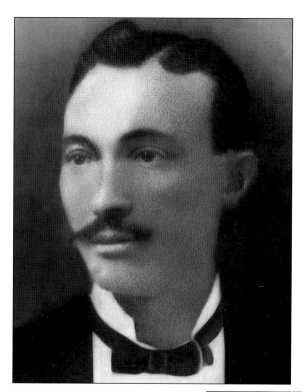

Andrea Camera (1861–1918), professor, composer, and conductor, played for Pres. Theodore Roosevelt and performed and collaborated with John Philip Sousa. He arrived in Little Italy from Amalfi, Salerno, c. 1880, lived at 283 Mott Street, and was naturalized in 1886, sponsored by his neighbor, manufacturer Alphonso Brocco. He married Luisa Gambardella and died of influenza in 1918.

Rina Telli, known for her beautiful voice, sang in many music halls and variety shows around town. She is costumed for the role of Santuzza in the popular and often performed opera adaptation of Giovanni Verga's drama *Cavalleria Rusticana*. Italians loved opera but could not afford the admission prices of the Metropolitan and Carnegie Hall, so smaller opera companies mounted economical productions accessible to the immigrants.

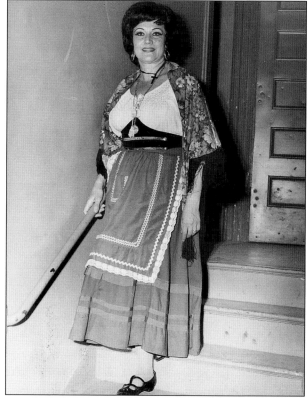

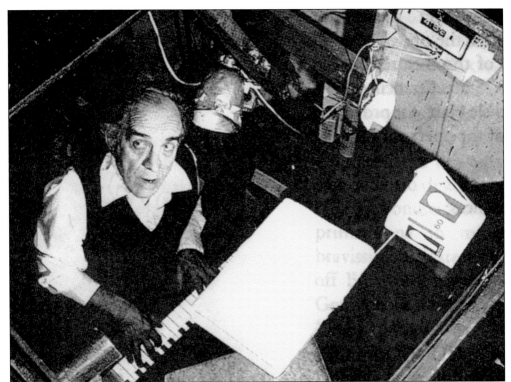

The Amato Opera Theatre, at 319 Bowery, is a miniature jewel box of a theatre, with only 107 seats and a stage only 30 feet wide. The tiny orchestra pit holds at most six musicians. As such, it is probably the smallest opera house in the world. Anthony Amato (above) came from Italy at the age of seven, the son of a butcher, an amateur opera singer who loved opera and instilled the passion in his son. When Amato and his wife, Sally (right), decided to commence production in the early 1950s, the maestro also established a conservatory and performance lab, to which many young people from the Bowery neighborhood came for instruction. He has a rotating casting system, allowing many to perform in leading roles. Sally, his partner in the company, works on public relations, costumes, and props.

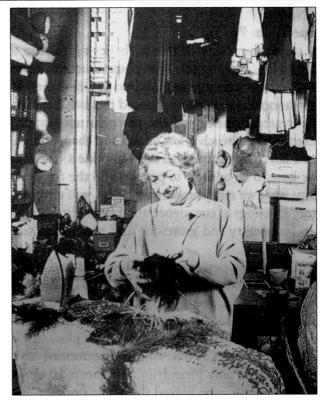

In 1900, the Italian marionette theatre was performed in warehouses and lofts by families in the profession for generations. A Teatro delle Marionette gave performances at 9 Spring Street, another on Mulberry Street performed in the Neapolitan dialect, and the one at 258 Elizabeth Street, owned by G. Rubino and D. Porrazzo, catered to Sicilian audiences. The Sicilian Agrippino Manteo immigrated via Argentina in 1919. He operated the Teatro Dei Pupi at 109 Mulberry Street until 1936.

Frizzi & Lazzi, the Olde Time Italian-American Music & Theatre Company, works at reproducing the original entertainments created by Italian immigrants at the beginning of the 20th century. Here, the character of La Strega (the Witch) narrates for children *The Legend of La Befana*, the traditional Italian story about the good Italian Christmas Witch who visits children on the eve of the Epiphany, Twelfth Night, and leaves presents for good children or stones for bad ones.

Seven

BUSINESS

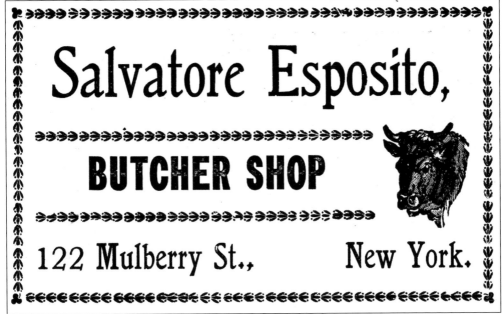

People from all over the world have come to New York to make money since the first Dutch settlers. The Italian immigrants were no exception; they worked for others and when possible they worked for themselves, establishing businesses of all kinds in Little Italy and its environs. This business card dates from 1907.

Ernesto Rossi started a general store, in which he also sold books, in 1902, after he had emigrated from Naples. In 1910, he relocated to 191 Grand Street, on the corner of Mulberry Street, where he established Rossi's Libreria (left), a music store and publishing company. The interior of the store (below) shows shelves of sheet music and books, piano rolls (the small, rectangular boxes on the top shelves), and a piano for trying out music. Along with books, music, and chapbooks of all kinds imported from publishers in Italy, Rossi sold Italian-American published materials, many of which are still available today in the store. Rossi's store has become an institution, now operated by his son Luigi and grandson Ernie.

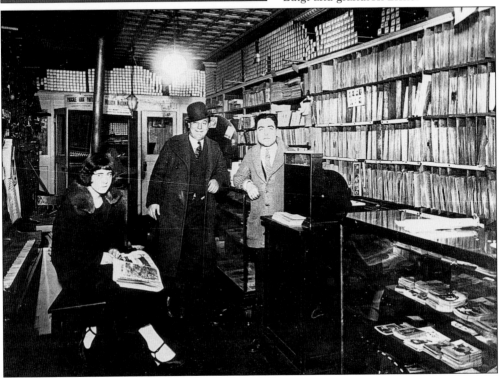

Books like these of Italian song collections were plentiful at Rossi's store, as well as at other bookstores in Little Italy. Italian traditional songs and latest hits were always in demand, but popular original Italian-American compositions were usually printed individually on single-page flyers or handbills, with music on one side and lyrics on the other. These two are typical chapbook examples. *Canzoni Italiane* (*Italian Songs*) (right) provided only the lyrics without the accompanying music; *Contrasto bellissimo tra un povero e un ricco che disputano chi di loro e piu felice* (*Magnificent debate between a poor man and a rich man, who argue about which of them is happier*) (below) is typical of a genre of duet by two singers. A *contrasto* could be argued by a city dweller and country peasant or a male and a female, for example, illustrating any opposing principles.

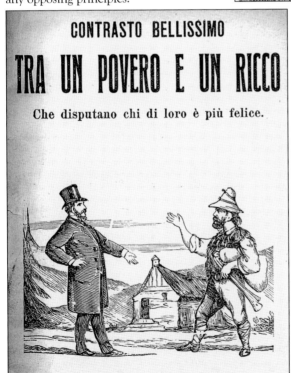

Angelo Alpi came from Piacenza, Emilia-Romagna, and entered the artificial flower industry. He owned an artificial flower manufacturing business, A. Alpi & Company, in the factory (below) at 69 West Houston Street, at Mercer Street. This room, for coloring and cutting artificial flower materials, has tables covered with bottles, pitchers, and bowls for coloring silk and trays of bits of silk waiting to be glued together to make flowers. Alpi, who stands second from the left, employed women and boys. His brother, Pietro Alpi, worked with Angelo when he arrived from Italy later. The company had sales offices in Paris, Chicago, and Montreal.

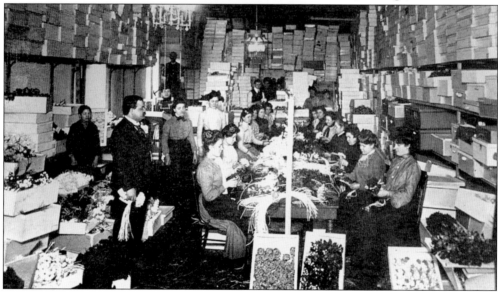

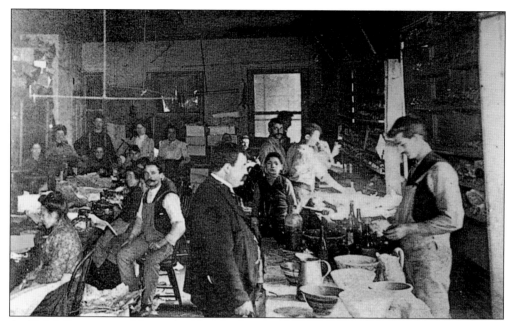

Artificial flower assembly at A. Alpi & Company was conducted in this workroom. The photograph shows a number of women seated at a long table working with fabric, wire, and a large number of boxes. By 1880, Italian women were dominating the artificial flower- and paper box-making industry in Little Italy.

The harp guitars in M. Iucci's advertisement sold for $15 to $40 and were guaranteed for five years. M. Iucci also sold mandolins and made repairs. Italo-Americanese, the developing English-Italian language mixture, creeps into this 1907 advertisement. The guarantee in the upper right corner is called a "ticket," and the ad notes the *Fabbrica* (factory) *e* "Store." By 1921, M. Iucci sold banjos, as the "inventor of the bell tone for snappy sound."

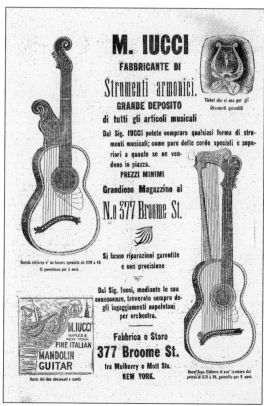

Luigi Peirano erected this seven-story, double tenement with a shop on the ground floor at the corner of Bayard and Baxter Streets *c.* 1906. A U.S. flag flies from the roof. Peirano was born in 1854 in San Rufino di Leioi, Liguria, and arrived in New York in 1871. In 1873, he opened a store on Park Street (formerly Cross Street) and then owned both building and store at 32 Mulberry.

Pasquale Margerella maintained his six-story chocolate factory (right), his distribution warehouse, and his administrative offices at 477–481 Broome Street in 1921. He was born in Spinoso, Potenza, in 1882, and came to New York in 1898 with little money or support. However, he was only 16 years old and in good health. He did whatever work he could get and managed to save his earnings, since he was alone and had few expenses. He saw how other Italians were succeeding in the candy business, so he took his savings of a few hundred dollars and opened a small store in the basement of 182 Varick Street. At first he did not do well, but he persevered and eventually managed to get credit. Finally, in 1914, he was able to secure the factory on Broome Street. By 1921, he was producing 30,000 pounds of chocolate a day and his factory was worth $250,000. He contributed to various Italian charities, donating $5,000 for the blinded Italian veterans of World War I.

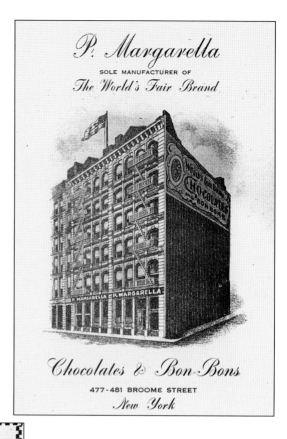

Prof. M. Longo had a business at 366 Broome Street where he produced Vitalb Longo, a tonic that he promised, though did not guarantee, would "immediately" stop hair from falling out. It also cured dandruff, all for the price of $1 per bottle, plus 25¢ postage and handling. Longo needed sale agents, as per the advertisement.

Calogero Mandracchia emigrated at the age of 12 from Sciacca, Sicily, to Elizabeth Street. An enterprising individual businessman, each morning he would shop for fresh fish at the Fulton Street fish market, at South, Fulton, and Beekman Streets, and return to peddle the fish on Elizabeth Street in the tradition of so many Italian pushcart vendors decades earlier.

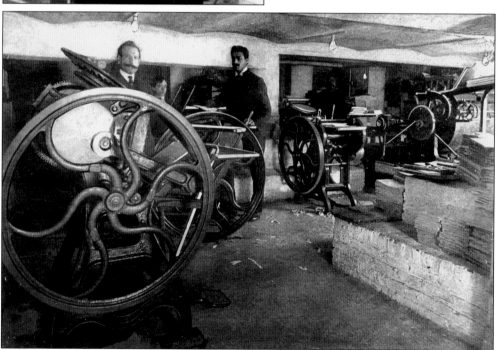

Francesco Tocci combined his principal business, a printing plant and bookstore, with other smaller businesses, including sales of musical instruments, at his Emporio Italo-Americano, at 520–522 Broadway, c. 1906. The building housed his office (with a Persian rug and cat), a salesroom, a showroom, and a room for printing presses (above). He employed four women and seventeen men.

Sensational and melodramatic stories and novels were printed in Italy on cheap yellow paper, hence the genre *libro giallo* (yellow book). Such chapbooks were printed here by publishers such as Tocci or were imported from Italy. The term was also applied to plays. A *dramma giallo* (yellow drama) was any exciting and sensational theatre piece. The novella *La Sepolta viva ovvero Lo Scheletro vivente* (*The Woman Buried Alive* or *The Living Skeleton*) (right) tells the story of a woman who lived beneath the ground for four years, surviving on only bread and water. The novella *Storia del brigante Antonio Gasparone* (*Story of the Brigand Antonio Gasparone*) (below) recounts how Gasparone and his six companions were freed in Rome after 47 years in prison.

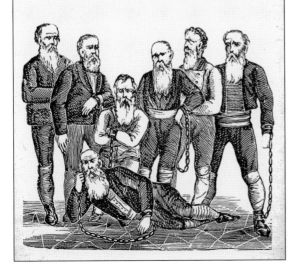

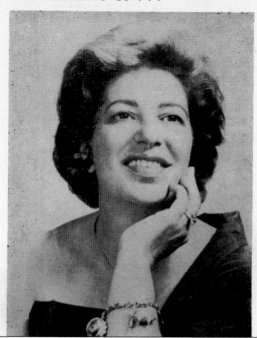

In 1900, Antonio De Martino's Societa Libraria Italiana (Italian Book Company), at 145–147 Mulberry Street, was the sole agent in the United States for the Italian music publisher Epifani. In 1907, the Excelsior Cinematografo was installed for a time as well. By 1959, Antonio's descendant Lyvia De Martino ran the business, which by then was known as Libreria De Martino. In the 1960s and early 1970s, Lyvia broadcast the program *Radio Italia* for radio station WHBI from this address.

Italian novelty books like this one were available at the Libreria De Martino. The cover features a magician, his props, and his assistant. The title of the book is *Libretto Magico del Cavalier Bosco* (Magic Book of Sir Bosco). Bosco wrote the book to teach card tricks, magic tricks, and sleight-of-hand, all of which to perform during social gatherings.

NINO D'AURIA

PRESENTA

PIEDIGROTTA A MARE

SOTTO GLI AUSPICI DELLA

ITALIAN ACTORS UNION

DOMENICA 7 SETTEMBRE

1969

SUL PIROSCAFO

BAY BELLE

SOUND STEAMSHIP LINES — "NAPOLI CANTA" SHOW BOAT

Partenza da Battery Park ore 10 a.m. - Ritorno ore 9 p.m.

BIGLIETTI (Adulti) $5.50 - Ragazzi, non oltre 12 anni, $2.50

Per biglietti e informazioni telefonare a:

NINO D'AURIA, Telefono: CL 6-4611

I biglietti potete acquistarli presso:

LIBRERIA DE MARTINO, 145 Mulberry Street, N. Y. — Tel. CA 6-8106
CAROSELLO MUSICALE, 105 Mulberry Street, N. Y. — Tel. 925-7253
E. ROSSI CO., 191 Mulberry Street, N. Y. — Tel. CA 6-9254
FORZANO ITALIAN IMPORTS, 128 Mulberry Street, N. Y. — Tel. 925-2525
E. ROSSI, 127 Mulberry Street, N. Y. — Tel. CA 6-6556
MERCORELLA TRAVEL AGENCY, 187 Court St., Brooklyn, N. Y. — TR 5-2805
AZZURRA MONDELLO, 306 Knickerbocker Ave.. Brooklyn. N. Y. — Tel. 497-9664
S.A.S. MUSIC STORE, 7117 - 18th Avenue, Brooklyn - Tel. 331-0540
CAPRI UNIVERSAL, 608 E. 187th St., Bronx, N. Y. - Tel. 298-1843

Direzione Artistica

RALPH MANFRA

Alle ore 12.30, nel grande Picnic Grove di Rye Beach, con molte tavole e sedili, potete mangiare all'ombra degli alberi.

Many Little Italy businesses helped sponsor this 1969 boat ride on the *Bay Belle* for the community: both of the Rossi brothers stores—Eduardo, at 127 Mulberry Street, and Ernesto, at 191 Grand Street; the Carosello Musicale, at 105 Mulberry; and Forzano Italian Imports, at 128 Mulberry. Nino D'Auria, the popular radio singer on stations WBNX, WHBI, WLDB, and WHTE, organized the event *Piedigrotta a Mare*.

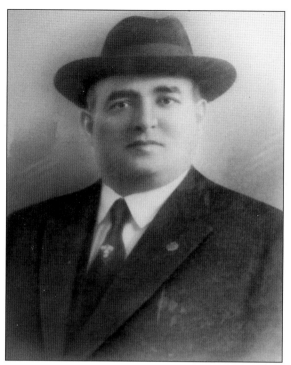

Antonio Ferrara (left) was both a businessman and an active community leader, his name appearing frequently throughout pages of Italian dailies. The success of his business enabled him to participate in charitable causes; he belonged to several community organizations. He was chairman for the Festival of the Tiro a Segno Nazionale Italiana (the Italian Rifle Club) and honorary president of the Circolo Alessandro Salvini in 1904. He assisted the committee of the Italian Tailors' Mutual Benefit Society fund in 1905, helped fund repairs for a home damaged by fire in 1903, and assisted the American Red Cross fund for the Triangle Shirtwaist Fire Victims in 1911. He also tried his hand, less memorably, at entertainment. His *caffe* (below), celebrating Thanksgiving in 1940, was his success.

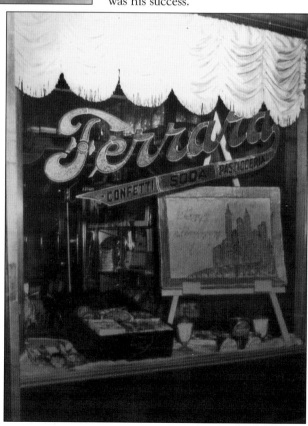

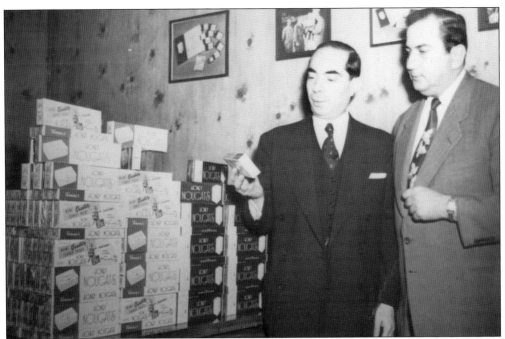

Antonio Ferrara's nephew Pietro Lepore (above, left, in the 1950s), also from Avellino, arrived in New York in 1930. He had stowed away as a clown on a ship carrying a circus troupe to New York and jumped ship. He went to work for his uncle and in 1932 married Ida, the daughter of Ferrara's partner, Enrico Scoppa. At the beginning of the 20th century, living quarters were above the store, but eventually the store offered the upstairs area for meetings. After Ferrara's death in 1937, Pietro bought out Enrico's interest and assumed control of the business. Before World War II, his strategic purchase of sugar protected the company during rationing. Pietro started shipping the nonperishable *torrone* during the war, resulting in today's successful mail-order division. The storefront (below) is pictured in the 1960s, when Pietro's sons Anthony and Alfred joined the company.

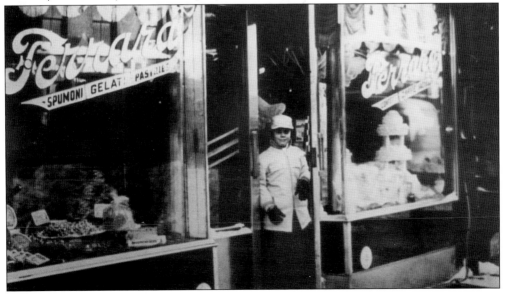

F. Leone Sanna, successor to the Sanna import-export company, was housed at 205 Grand Street in 1921. The Roma Radio and Furniture Company, now gone, later became an institution at that address. Frank Iuculano served as president of the business until 1958, succeeded by Thomas Iuculano in 1959. Roma's showrooms were located at 205 Grand Street, and the factory at 213–215 Grand Street. The company provided free parking for customers and was open Monday through Saturday, eventually opening seven days a week. Roma sold bedroom, living-room, and dining-room sets, refrigerators, washing machines, radios, televisions, and various home appliances. When it closed c. 1980, the residents of the neighborhood felt that they had lost an old friend, that one more piece of Little Italy had disappeared.

Eight

EXODUS

Five Points was always a place for immigrants: German, Irish, Chinese, and Italian. The immigration quota laws that went into effect in 1924 restricted the annual importation of new Italians into the United States to two percent of the number that entered in 1890, which was not a heavy year. Little Italy was eventually greatly affected. Also, as time went on, the need for an exclusively Italian neighborhood was lessened by the Italians becoming more acculturated. The building at 198 Grand Street (above), between Mott and Mulberry, was Donna Concetta Bergamo's Bar & Restaurant in 1894, Domenico Volpe's Villa Giulia in 1900, Gaetano Borriello's Villa Napoli in 1904, Raffale Penza's Villa Penza in 1905, Pietro Sirignano's Manhattan Amusement Cinematograpfo in 1907, and Villa Pensa—its last name before becoming a Chinese business.

Fausto D. Malzone of Castellabate operated his Banca Malzone from 1886 to 1902 in this building at 88 Mulberry Street, between Canal and Bayard Streets. His shieldlike sign is seen in the picture on page 19, taken when this area was the heart of the banking business. The building is now a Chinese butcher shop, reflecting the neighborhood's ethnic change.

Currently, the Chinese Musical and Theatrical Company occupies this building on the Bowery between Grand Street and Broome Street. Another example of the ethnic changes, 138 Bowery was called by the generic Teatro Italiano or the Drammatico Nazionale in 1903 and 1904, under the impresarios Antonio Maiori and Pasquale Rapone.

South Brooklyn had many advantages as an alternate neighborhood for Italian-Americans: its proximity to the city and to the docks, where many Italians found work as longshoremen. The Mercorella Travel Agency and Insurance and Law Office was operated by Alfonso Mercorella. Located at 187 Court Street, at Bergen Street, it was close to both the Italian enclave and the downtown Brooklyn court district.

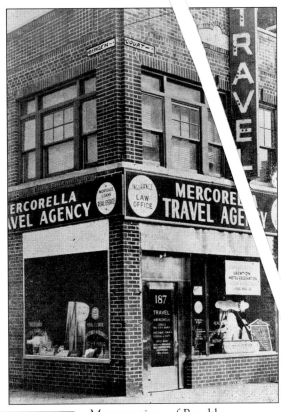

Many sections of Brooklyn developed pockets of Italian neighborhoods. At 1803–1805 Broadway, Edmondo Nigri ran the Nigri Furniture store, "the Italian store for Italian-Americans." His son Joseph was the general manager. Their rhymed slogan promised *"Chi buona mobilia voul comperare, da Nigri deve andare"* (Whoever wants to buy good furniture, must go to Nigri's).

COMM. EDMONDO NIGRI
President

JOSEPH NIGRI
General Manager

"CHI BUONA MOBILIA VOUL COMPERARE
DA NIGRI DEVE ANDARE"

NIGRI — la Ditta Italiana per gl'italiani d'America

BUY-WITH-CONFIDENCE
USE-WITH-PRIDE

NIGRI FURNITURE
WHERE-YOU-BUY

COMPLETE
HOMES
FOR
NEWLYWEDS

Better FURNITURE
For LESS

DA NIGRI SI E' TRATTATI DA AMICI NON DA CLIENTI
MOBILIA DI ALTA QUALITA'

125

Actor Guglielmo Ricciardi (left) made it to Hollywood and secured a contract with Universal Studios. He appears here as the maestro in *Stars over Broadway*, with Pat O'Brien (center) and James Melton. He acted in the silent film *The Humming Bird* with Gloria Swanson and his friend from Sorrento, Italian actor Cesare Gravina. He also played the opera impresario in the classic *San Francisco*, with Clark Gable and Jeanette McDonald.

The D'Aleo family and relatives, including the La Barberas of Elizabeth Street, enjoy a Sunday on Staten Island, where the D'Aleos bought a home in 1939. Staten Island, with its rolling hills, attracted many Italian-Americans, who remain generations later and make up a sizable portion of the population. On Staten Island is located the Garibaldi-Meucci Museum, the home where Garibaldi lived in the 1850s with Antonio Meucci, the inventor of the telephone.

The Bronx attracted many Italians. The Belmont section became another Little Italy. After the death of her husband, Vladimiro, in 1919, Emma Lutterotti, shown here in mourning dress, moved with their daughter, Elodia, to the Woodlawn section of the Bronx, another Italian enclave. Emma died in 1936; Elodia, still a teenager, went to live with the Lamanna family in the Castle Hill area and then with the Lutterotti family in Italy.

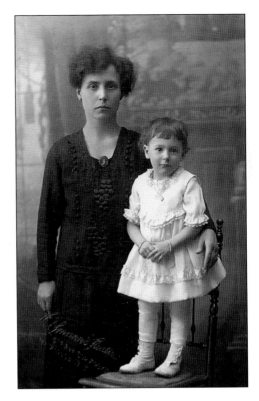

La Sorrentina (Woman from Sorrento) was the stage name for Maria Frasca, a singer on the Italian music hall circuit. As Italian audiences dwindled and vaudeville shows disappeared, she moved to the Bronx, where she opened a restaurant, Scotti's, at 3141 East Tremont Avenue. She sometimes performed her old repertoire there, with Ernesto Migliaccio at the piano.

When Marietta La Barbera and Joseph Ligammari got married, they moved to Chicago in 1923 for his work as a barbershop supplier. They prospered well enough there to afford an automobile. After Joseph's death, Marietta returned to Elizabeth Street but later relocated to South Brooklyn to marry longshoreman Ciro Nasti.

Many longtime residents of Little Italy remained in the neighborhood until the end of their days. Unavoidably, they were escorted out by Bacigalupo or his colleagues, since no active cemeteries were located in Manhattan, let alone the neighborhood. Immigrants found their resting places outside the city, in the other four boroughs, on Long Island, or in Westchester County.